DD	DV	DS		
6/05			12/05	
DL	DW			
9/06		3/06	4/07	
DM	DX	BM	BY	
4/08				

MOODS OF THE
BRECON BEACONS

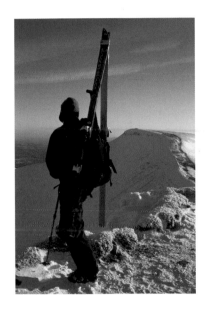

TOM HUTTON

HALSGROVE

First published in Great Britain in 2004

Copyright© 2004 text and photographs Tom Hutton

Title page: **Skier, Corn Du**

British Library Cataloguing-in-Publication Data
A CIP record for this title is available from the British Library

ISBN 1 84114 350 2

HALSGROVE
Halsgrove House
Lower Moor Way
Tiverton, Devon EX16 6SS
Tel: 01884 243242
Fax: 01884 243325
email: sales@halsgrove.com
website: www.halsgrove.com

Printed and bound by D'Auria Industrie Grafiche Spa, Italy

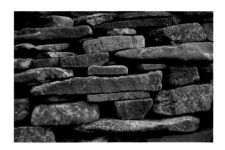

INTRODUCTION

Like a surfer searching for that perfect wave, I have devoted much of my life to seeking out a flawless, all-encompassing, single image of my favourite mountains; the Brecon Beacons. In folly, I believed that I could capture, on one tiny strip of celluloid, something that would somehow describe every breathtaking detail from the formidable grandeur of the precipitous north-east face of Pan y Fan, to the delicate fragility of the first few snowdrops of spring. One photograph that would somehow evoke the tranquillity of a small mountain llyn at sunrise while at the same time portray the merciless power of the cascading Afon Nedd Fechan in full spate.

The deeper I looked, the more impossible my task seemed until one day it dawned on me where I was going wrong; it wasn't the scenery that I needed to capture, it was the mood, the ambience, the very spirit of the place. And that was an ever-changing spectacle that no single image could ever do justice to.

It was time to alter my approach. Through my photography I learned to look at the landscape as a blank canvas. No matter how varied or spectacular the scenery might have been, it was still just the empty stage upon which the real dramas would unfold. Dramas of changing seasons; of rustic autumns and icy winters followed by colourful springs and verdant summers. Dramas of erratic weather patterns that would deliver sunshine, rain and snow in the same morning and that could turn drought into flood in a matter of just hours.

And most dramatic of all, the dramas of changing light; of dancing beams that spotlight individual summits, of rainbows that arc gracefully across slate grey skies and of winter sunsets that paint the snow-capped mountains pink. These were the true moods of the Brecon Beacons and it was these that I have endeavoured to portray.

Proud of it though I am, I won't try to pretend that this a definitive collection; I doubt that such a thing will ever exist. It is however the best that I've managed so far and the images that I've chosen certainly reflect my passion for this very special place.

I hope that viewing them will give you as much pleasure as taking them has brought me.

Tom Hutton, 2004

LOCATION
GUIDE

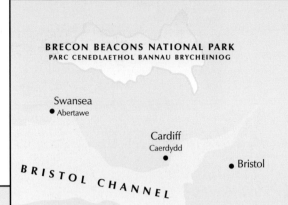

BRECON BEACONS NATIONAL PARK
PARC CENEDLAETHOL BANNAU BRYCHEINIOG

Swansea
● Abertawe

Cardiff
Caerdydd
●

● Bristol

BRISTOL CHANNEL

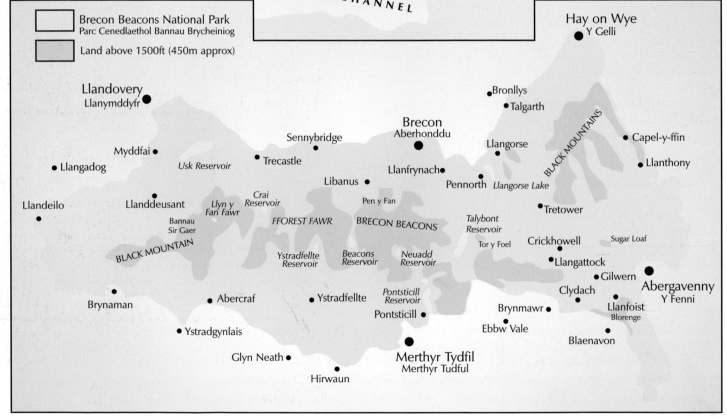

☐ Brecon Beacons National Park
Parc Cenedlaethol Bannau Brycheiniog

▨ Land above 1500ft (450m approx)

Hay on Wye
● Y Gelli

Llandovery
Llanymddyfr ●

● Bronllys
● Talgarth

Brecon
Aberhonddu ●

Llangorse ●

BLACK MOUNTAINS

● Capel-y-ffin

Sennybridge ●

Myddfai ●

● Llangadog

Trecastle ●

Usk Reservoir

Libanus ●

Llanfrynach ●

Pennorth ● Llangorse Lake

● Llanthony

● Llandeilo

Llanddeusant ●

Crai Reservoir

Pen y Fan

Llyn y Fan Fawr

Bannau Sir Gaer

FFOREST FAWR

BRECON BEACONS

Talybont Reservoir

Tor y Foel

● Tretower

Crickhowell ●

Sugar Loaf

BLACK MOUNTAIN

Ystradfellte Reservoir

Beacons Reservoir

Neuadd Reservoir

● Llangattock

● Gilwern

● Abercraf

● Ystradfellte

Pontsticill Reservoir

Clydach ●

Abergavenny
Y Fenni ●

Brynaman ●

Pontsticill ●

Brynmawr ●

Llanfoist ●
Blorenge

● Ystradgynlais

Ebbw Vale ●

● Blaenavon

Glyn Neath ●

Merthyr Tydfil
Merthyr Tudful ●

Hirwaun ●

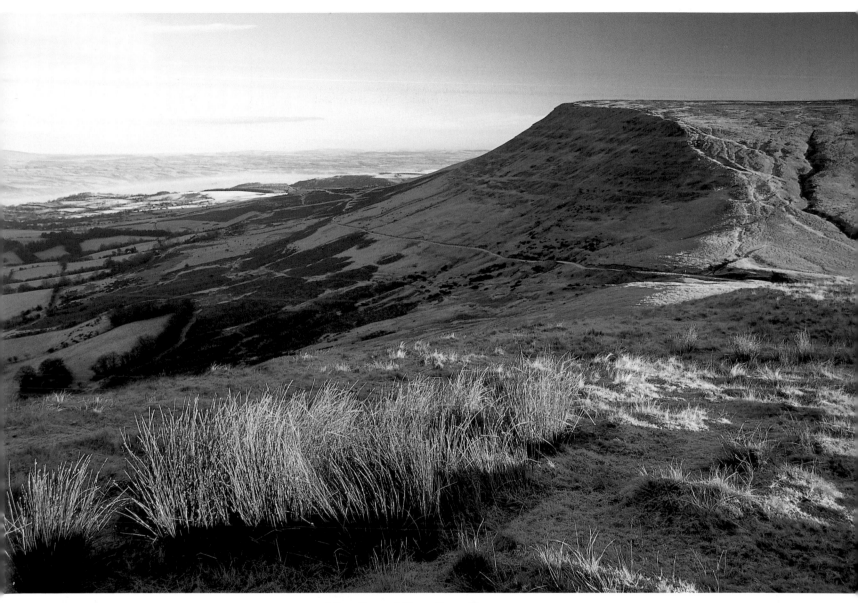

The Gospel Pass from Twmpa

A classic shot of a classic Black Mountains landmark. This wonderful ribbon of asphalt climbs up to an impressive 542m (1778ft) above sea level to straddle the Black Mountains between Hay Bluff and Twmpa. In summer it can get very congested with sightseers, but in winter you'll get it all to yourself.

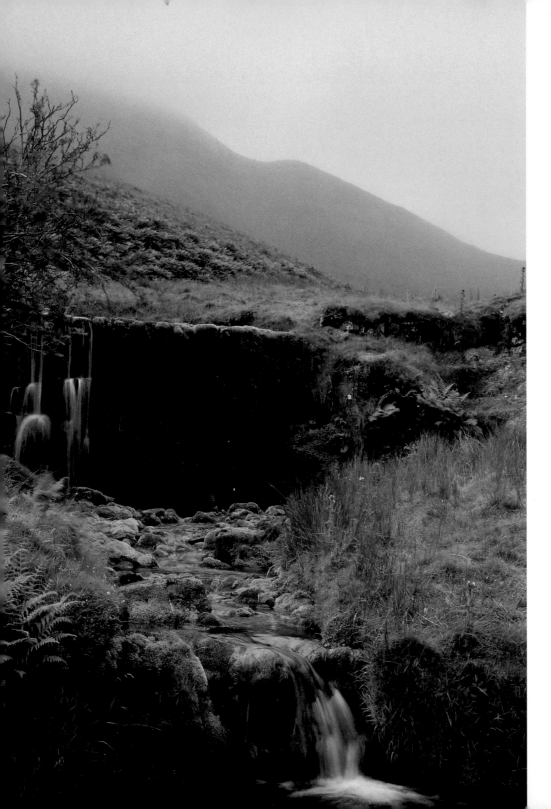

Nat Cwm Sere and Pen y Fan
With the peaks shrouded in cloud, these small falls on the Nant Cwm Sere make an ideal foreground to the backdrop of Pen y Fan.

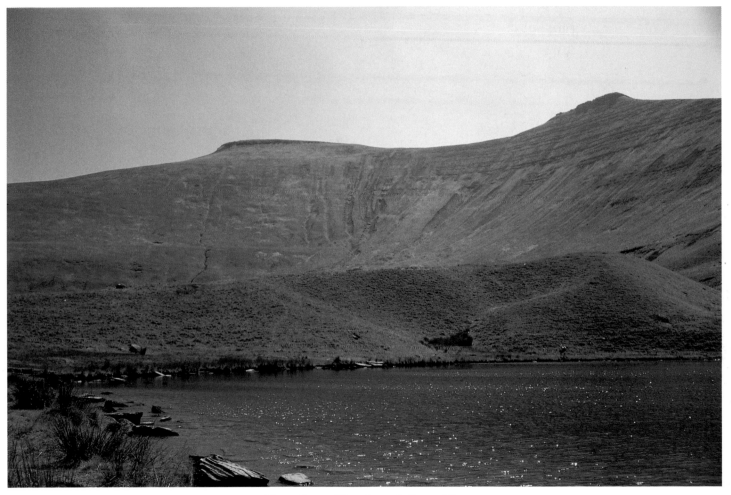

Llyn Cwm Llwch and Corn Du
Llyn Cwm Llwch is a typical glacier-formed tarn at the foot of Corn Du. It is a glorious
spot with the twin summits of Corn Du and Pen y Fan towering over your head.

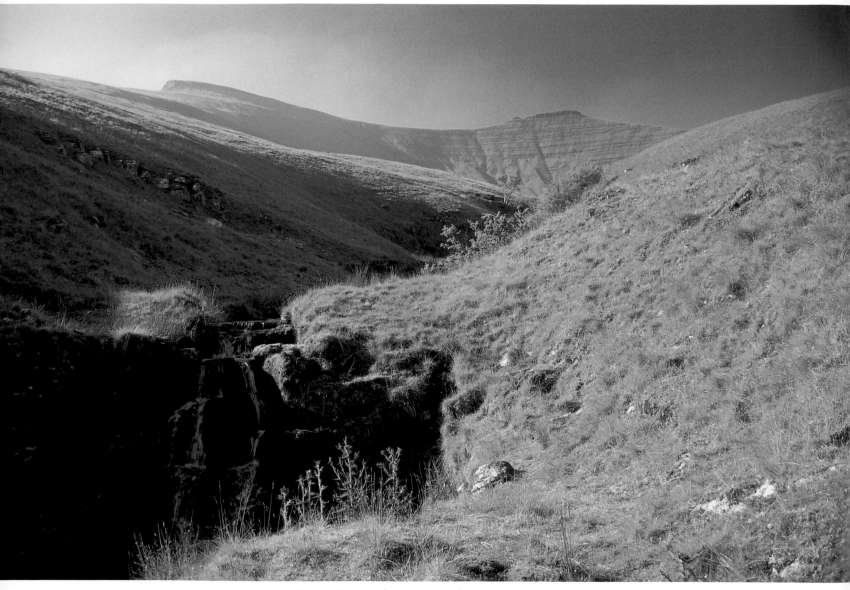

Pen y Fan and Corn Du from Cwm Llwch

In mid summer the mountain tops can get incredibly busy, so I chose instead to follow the Nant Cwm Llwch up
to its source beneath the big peaks. There are many delightfully secluded spots like this all the way up.

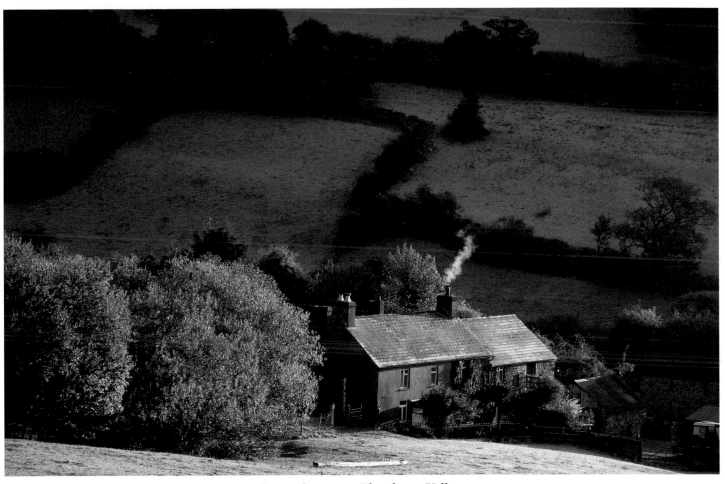

Farm Cottages, Llanthony Valley
You can almost smell the wood smoke rising from these homely-looking farm cottages in the Llanthony Valley. The sun takes a long time to probe deeply into some of the more sheltered spots beneath the mountains.

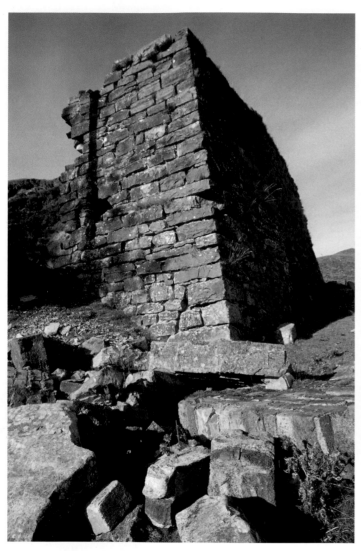

Quarry Ruins, Mynydd Llangattock
A ruined and long derelict quarry building on the
Llangattock escarpment. This last remaining wall stands
defiantly over its fallen comrades.

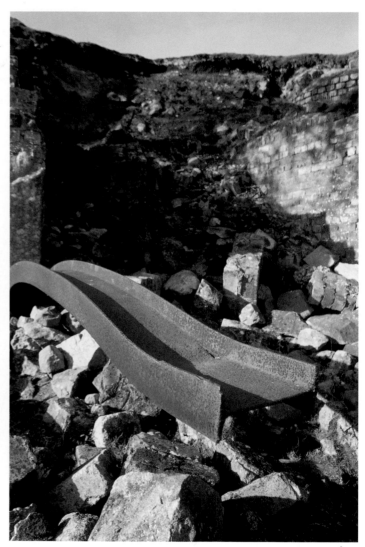

Iron stanchion, Mynyyd Llangattock
A twisted iron stanchion arches over the brickwork it once
supported. The rust provides a swathe of colour against the
grey of the limestone bank. Wherever you go in the National
Park, you're never far from the signs of human endeavour.

Grwyne Fechan Valley from Tal–y–maes Bridge
One of my favourite valleys in the Black Mountains, the Grwyne Fechan is particularly beautiful in autumn. It is a long pull from the pretty little bridge up to the high peaks at the head of the valley.

Autumn Birch, St Mary's Vale
Autumn foliage and a bright midday sun
make for a colourful portrayal of this silver
birch seen in St Mary's Vale.

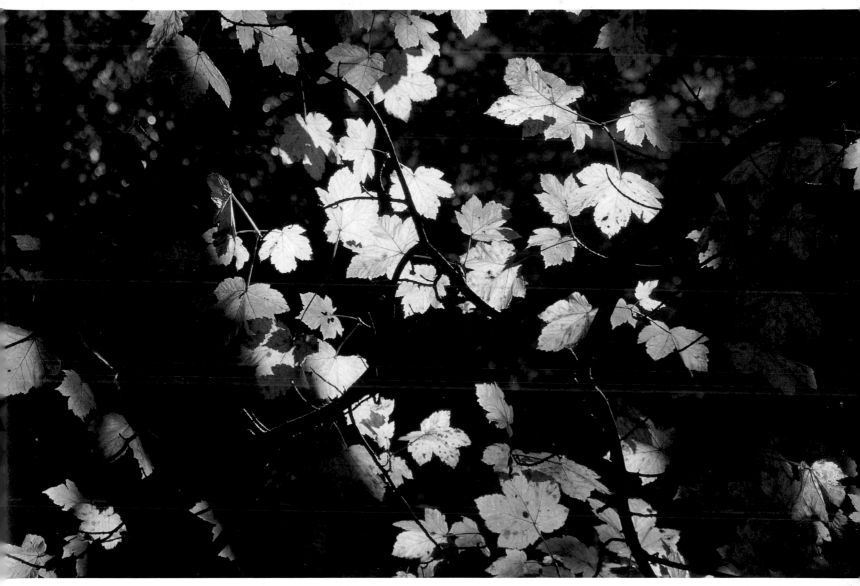

Backlit leaves, Caerfanell Valley
I really liked the pattern of these backlit leaves against the darkened trees behind. They were seen near the Talybont Reservoir.

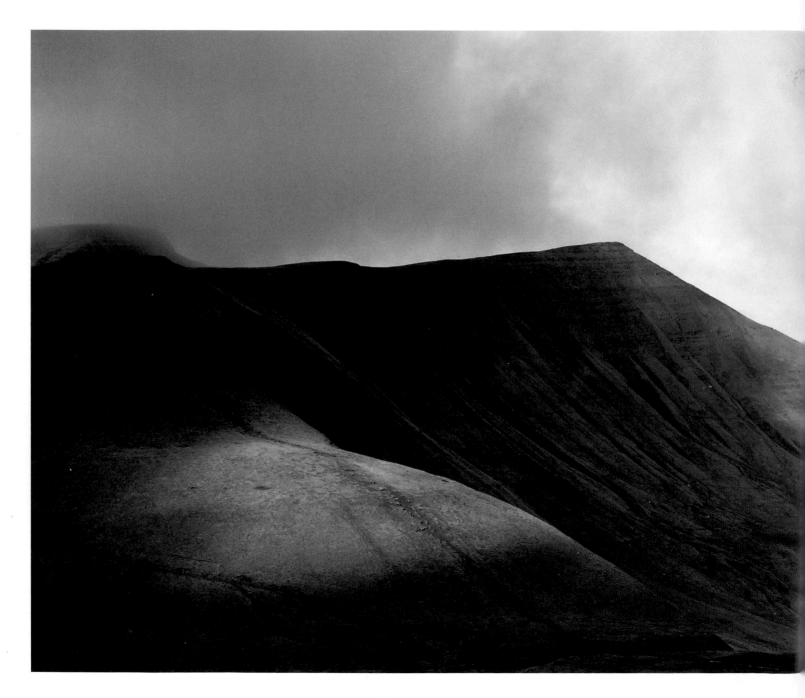

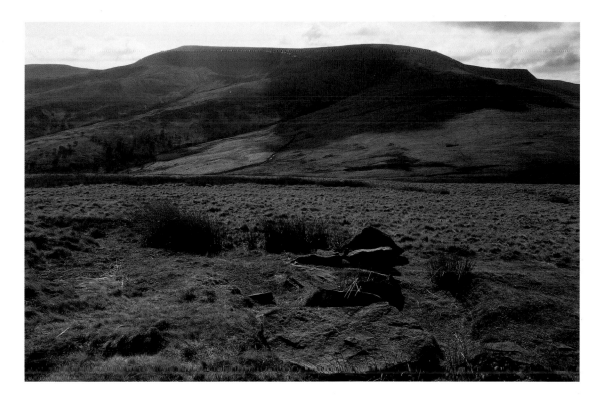

Above
Waun Rydd and Carn Pica from Pen y Bryn
Snow clings to the rim of the north-facing cirque, which is seen across the barren
moorland of Pen y Bryn. The sharp peak on the far right is Cribyn.

Left
Cribyn from Fan y Big
Looking across The Gap to Cribyn, I was taken by the beams of light which lit the
foreground ridge. The top of Pen y Fan can just be seen behind in the cloud.

15

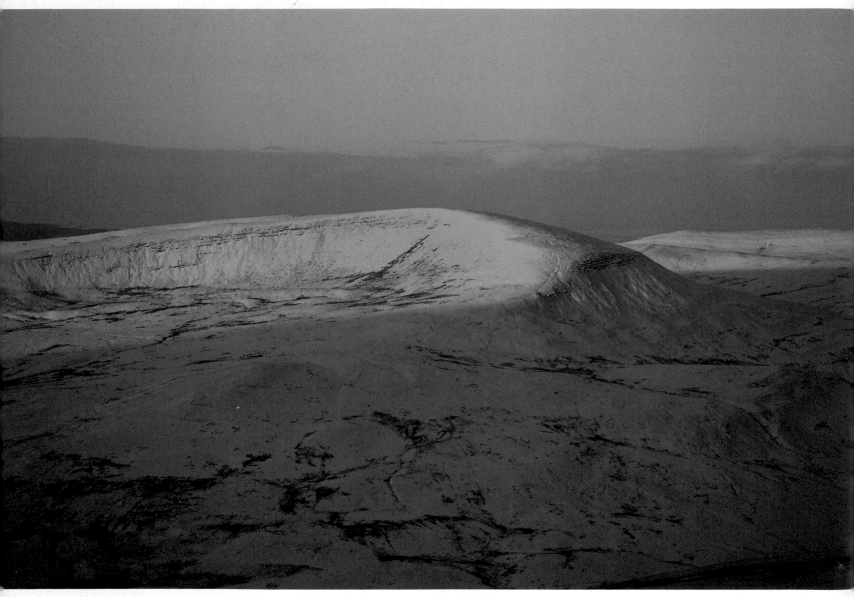

Fan Fawr

The highest of the Fforest Fawr peaks and the easiest one to access as it sits astride the main A470. This image was taken from Corn Du just after sunrise.

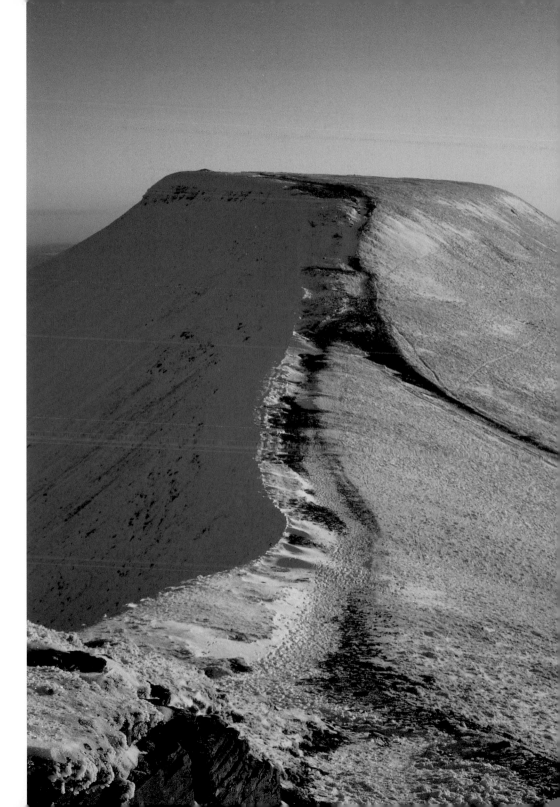

Pen y Fan from Corn Du
Pen y Fan in full winter raiment taken from a clod perch on the craggy east end of Corn Du. In a bad winter, huge cornices can build up over this sweeping escarpment edge.

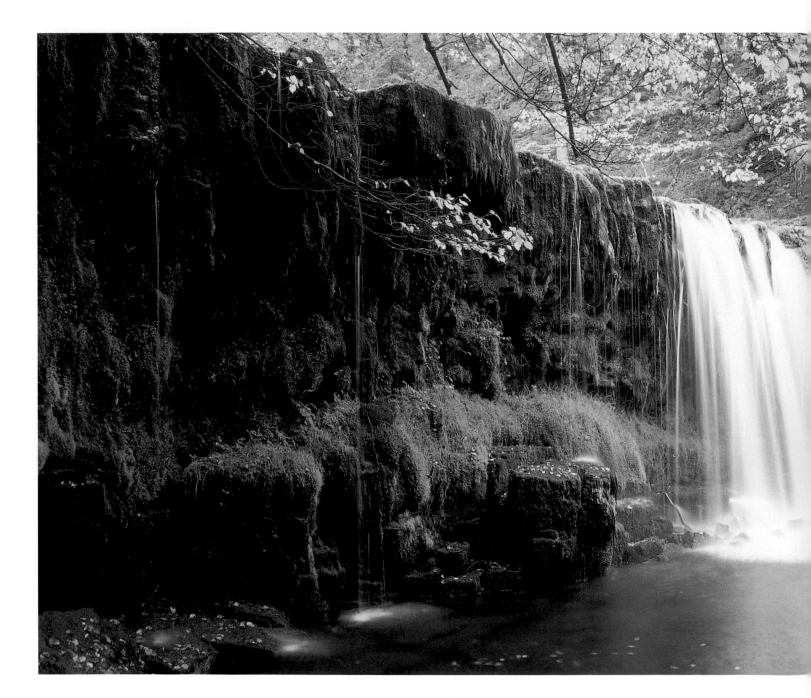

18

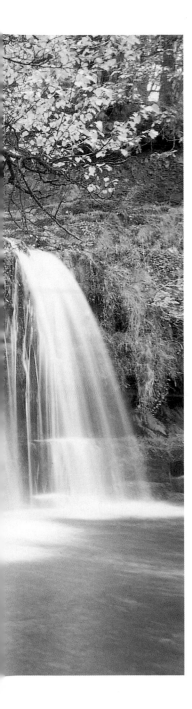

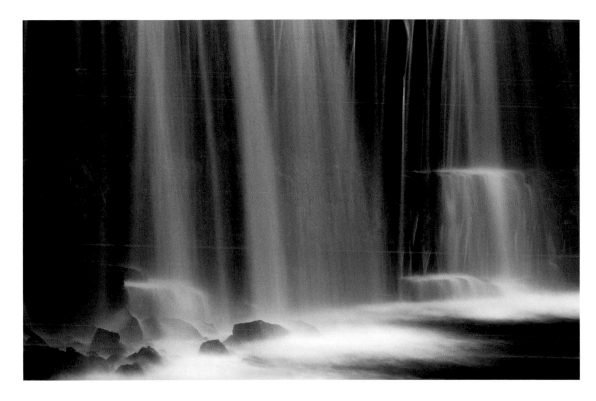

Above
Sgwd Ddwli, Afon Nedd Fechan
Sometimes less is more, as this tight crop on the foot of Sgwd Ddwli shows. Despite
showing little of the scene, the water falling on the jagged rocks makes a more
attractive image than a similar shot I took of the whole waterfall at the same time.

Left
Sgwd Ddwli, Afon Nedd Fechan
I love the way the moss-covered rock walls lead the eye to the main falls.
The whole scene is balanced by the autumn leaves hanging down.

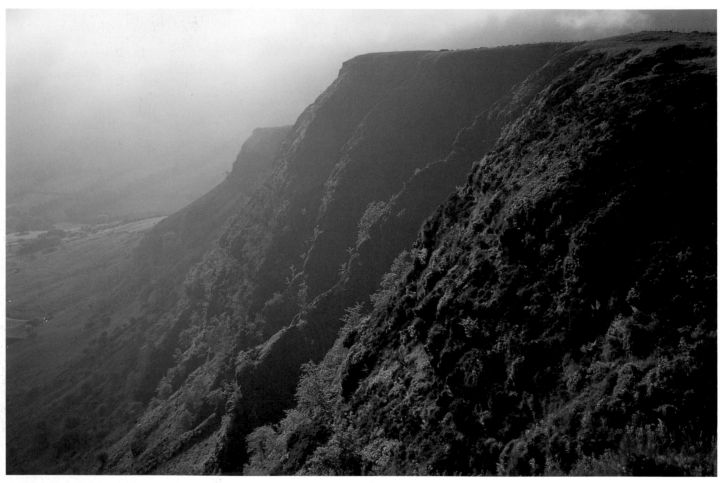

Craig Cerrig-gleisiad
The impressive green walls of Craig Cerrig-gleisiad shrouded in early morning mist.
While I was taking this picture, a peregrine falcon flew within a few metres of me. It
was so close that I could hear the wind in its wings. It really made my morning.

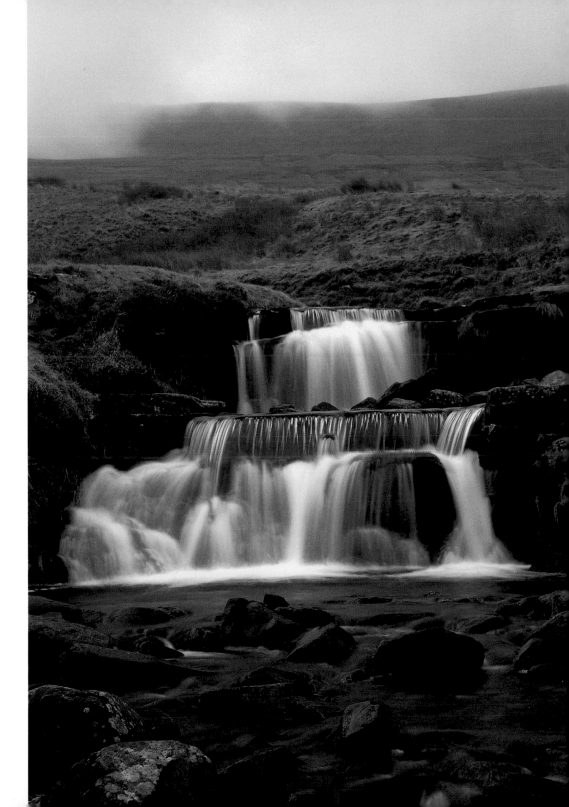

Waterfall, Afon Taf Fawr
Passed by literally hundreds of walkers every day as they make their way slowly up onto Corn Du and Pen y Fan, these small falls are an absolute delight. One wonders why more walkers don't take the short detour to enjoy them.

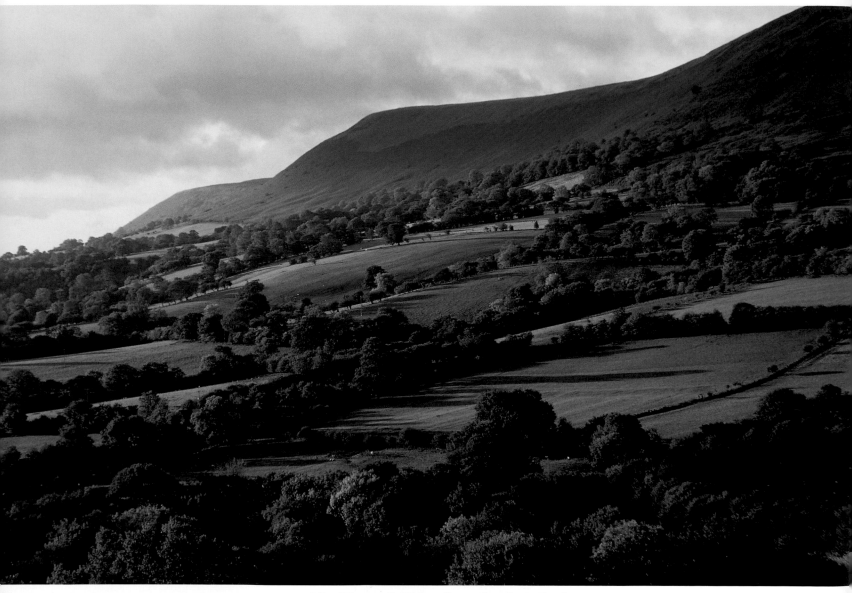

The Hatterall Ridge from the Cat's Back

Bright morning light accentuates the verdant summer greens of the trees and fields which
front the Hatterall Ridge. The Offa's Dyke National Trail runs along the ridgetop.

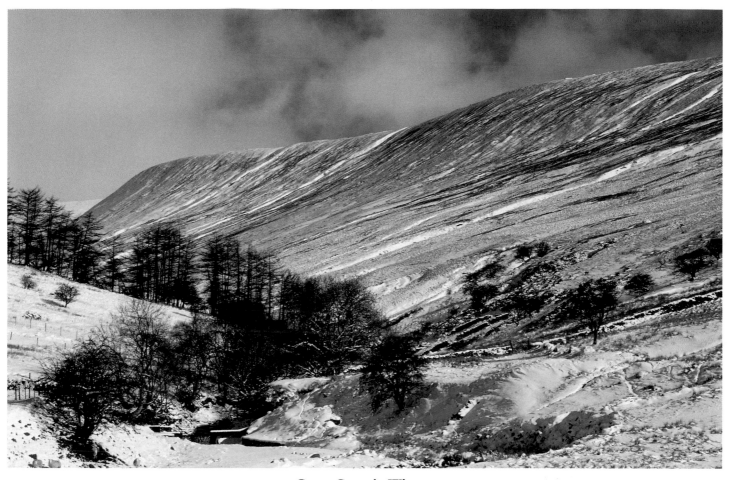

Cwm Crew in Winter

This stunning valley leads from the main A470 up to the highest peaks in the National Park.
The ridge on the right leads onto Graig Fan Ddu, the long escarpment that's usually
climbed from the Neuadd Reservoirs.

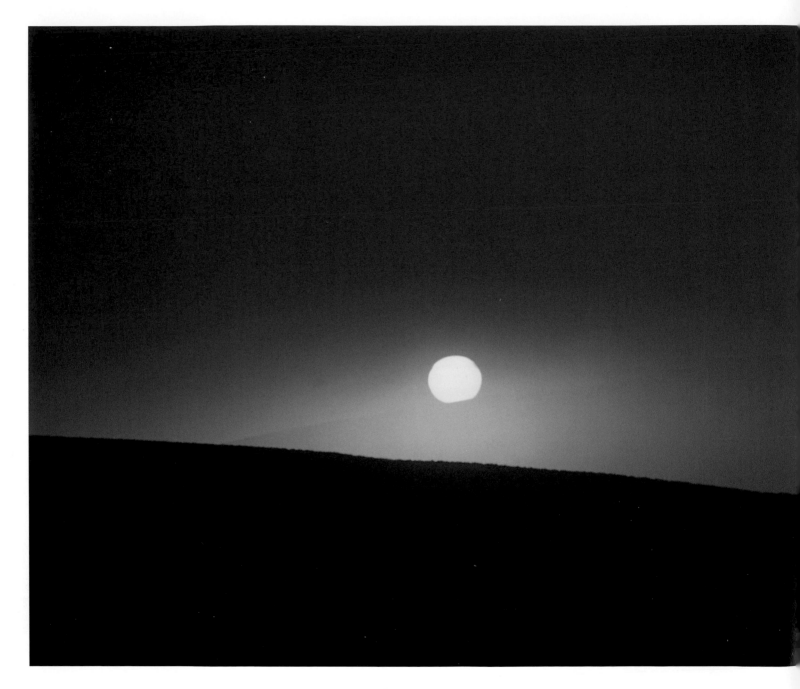

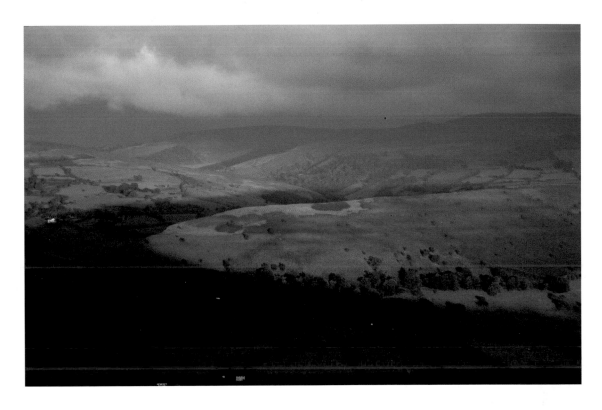

Above
Bryn Arw fromYsgyryd Fawr
The first few beams of light hit the blunt spur of Bryn Arw, casting deep shadows in the valley beyond. The farmhouses in the foreground give it a real sense of perspective.

Left
Sunrise over Fan Llia
The frustrations of being a photographer. Having slept in the car to be in situ for the sunrise over Fforest Fawr, I awoke to nothing but claggy cloud. The rising sun burnt through the cloud briefly and I took this shot. It then vanished and the shutter didn't click again all day.

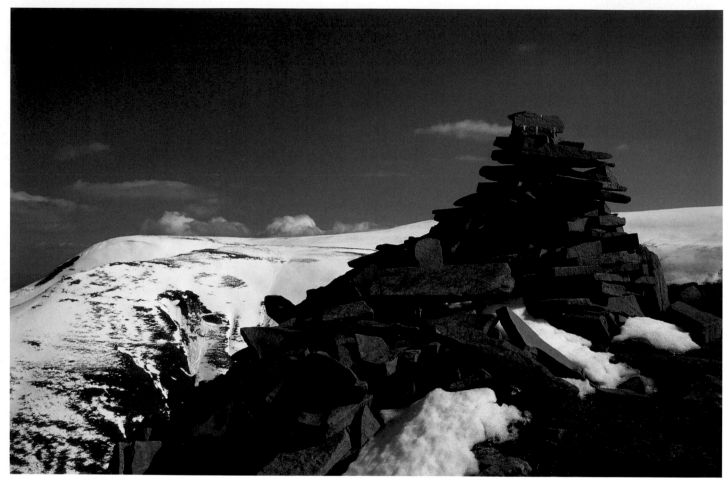

Y Crib, Black Mountains

The narrow spine of Y Crib is the nearest that the Black Mountains get to a knife-edge ridge, although it is really little more than a slender grassy spur. This cairn sits atop the highpoint and makes a nice focal point.

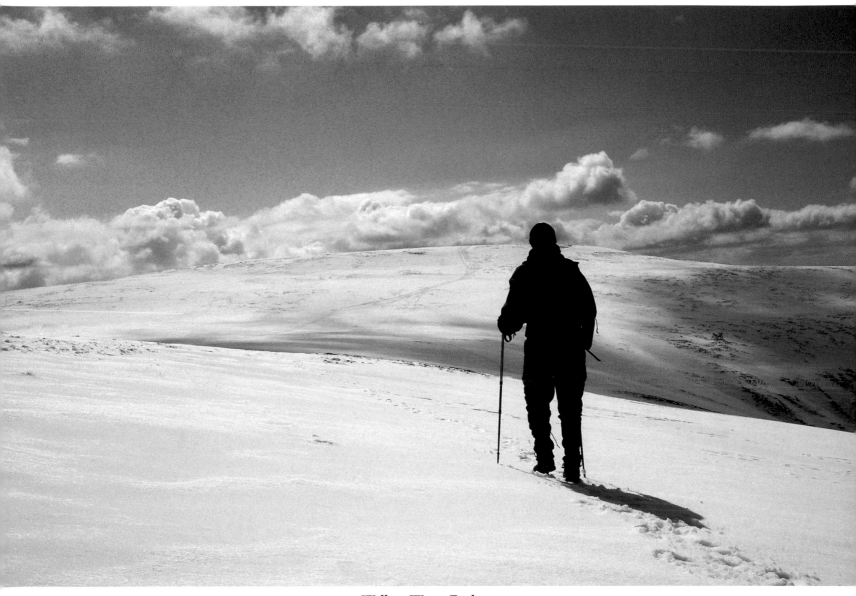

Walker, Waun Fach

Resplendent in its full winter coat, the bleak summit of Waun Fach could easily be mistaken for the Cairngorms.
Good visibility is essential up here when it is like this; the word featureless doesn't do it justice.

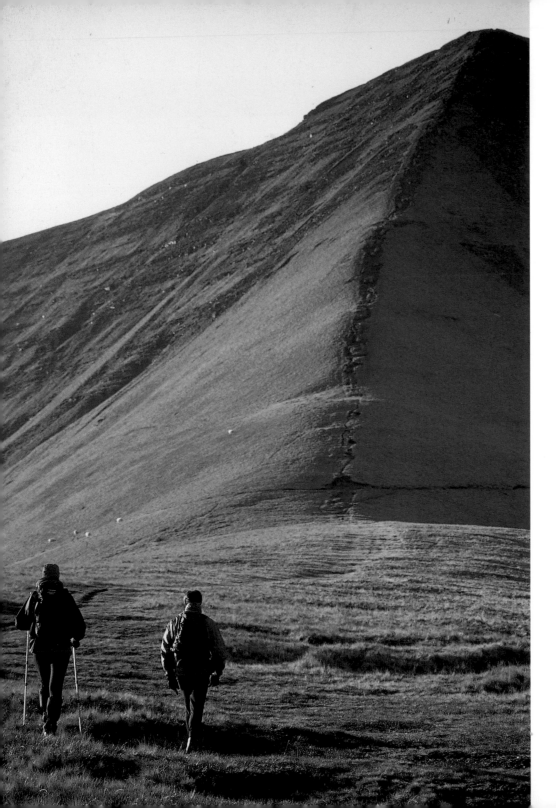

Walkers, Bryn Teg
A pair of walkers leave the airy ridge of Bryn Teg behind as they approach the steep final climb onto the compact summit of Cribyn. Often the bridesmaid but never the bride, Cribyn makes a fine alternative to the busy neighbouring honeypots of Pen y Fan and Corn Du.

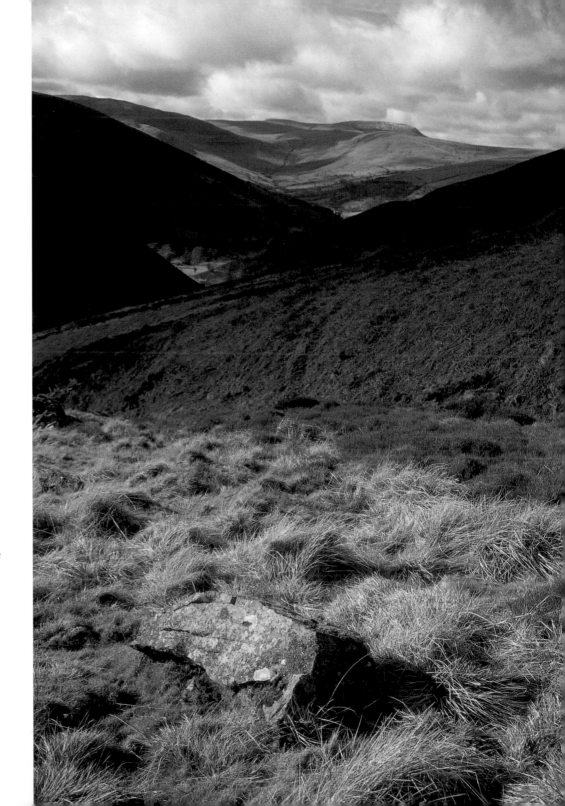

Senni Valley from Fan Frynach
Dramatic lighting adds to the austere
feel of this shot of open moorland
near Fan Frynach in Fforest Fawr.
The Senni Valley leads you nicely
from the middle of the picture to
the pronounced escarpment on
Fan Gyhirych.

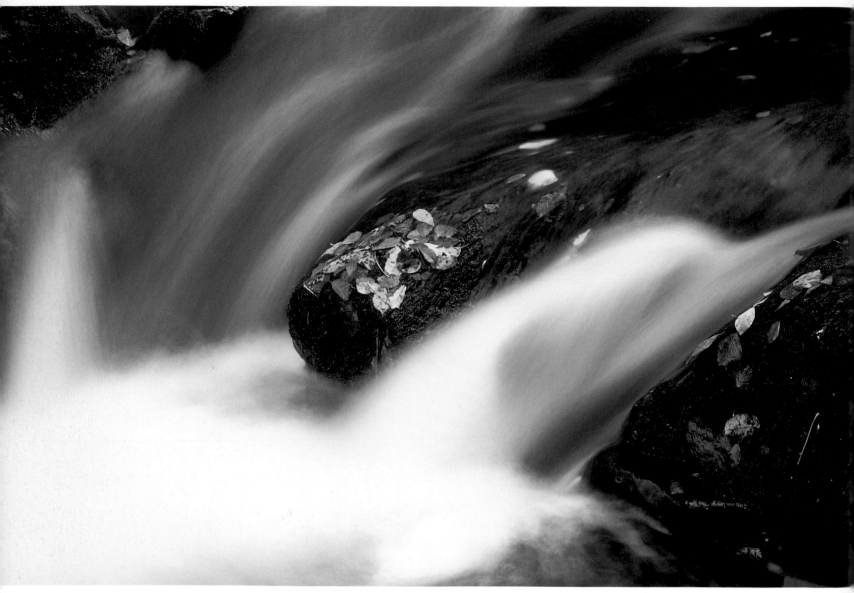

Waterfall and leaves, Clydach Gorge

Autumn brings much-needed rain to the rivers and streams of the area and suddenly there are
cascades and waterfalls springing up everywhere. This little beauty is on the Afon Clydach.

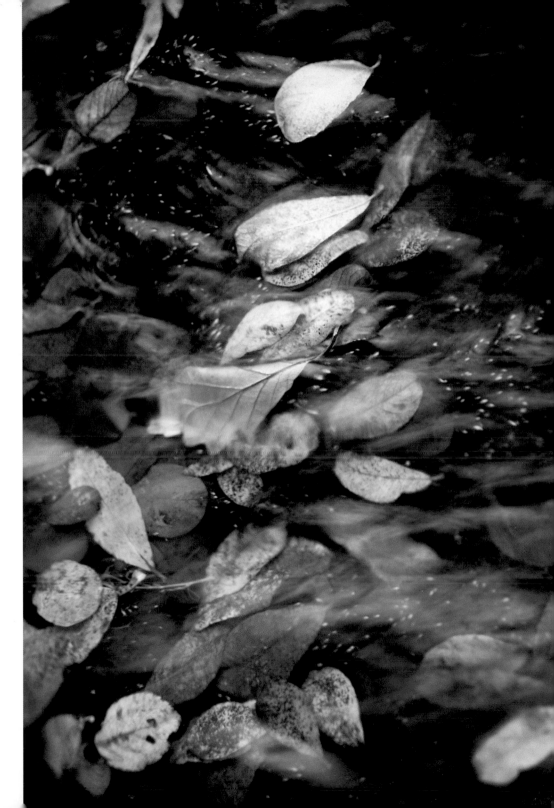

Leaves in the Afon Caerfanell
The autumn leaves drift downstream where they get caught up on rocks and other obstacles. The scene is the same in all the rivers of the National Park at this time of year.

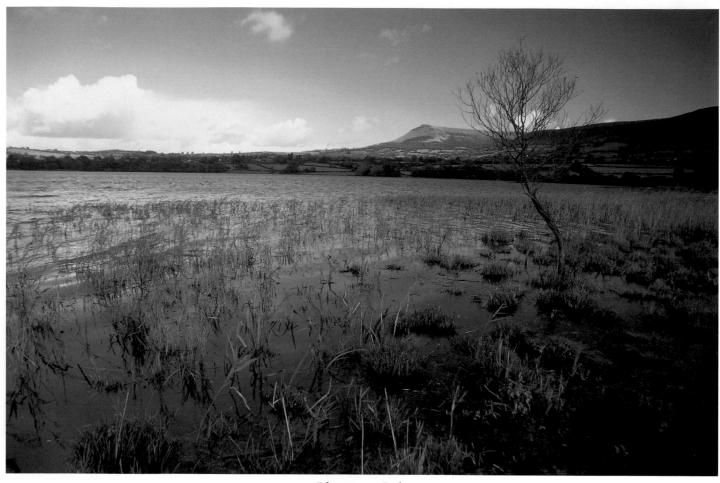

Llangorse Lake

Llangorse Lake is the largest natural lake in the National Park, and it is a haven for wildlife.
This view was taken from the southern shore looking north and east towards Mynydd Troed.

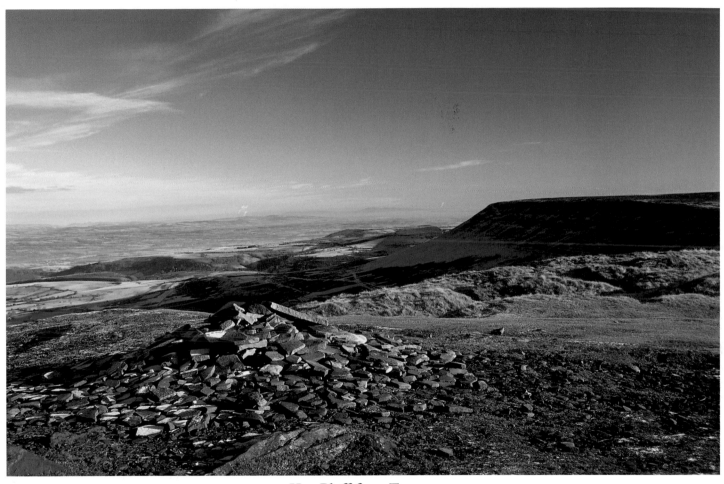

Hay Bluff from Twmpa

The north-east corner of the National Park is dominated by two mountains, Hay Bluff and Twmpa.
This shot looks from the latter across to the former. In the distance you can just make out the Malvern Hills.

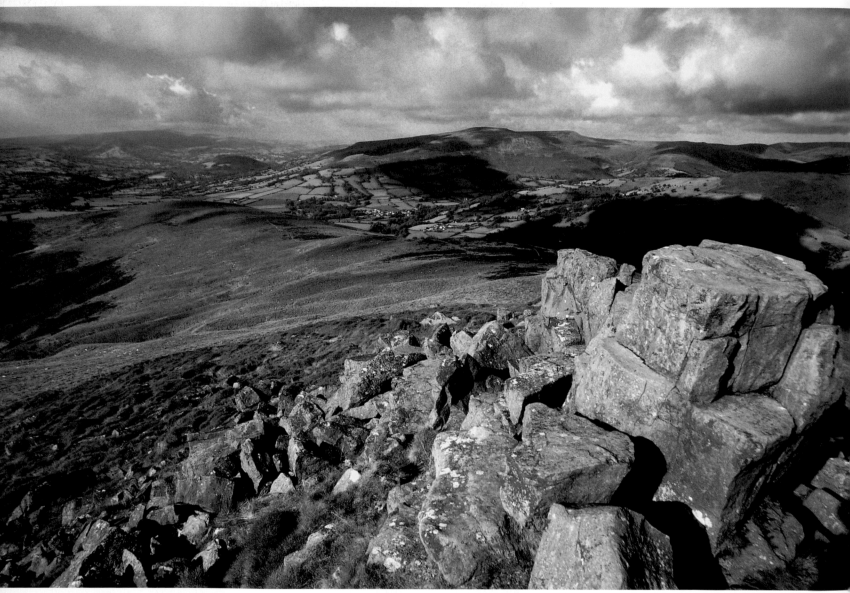

Summit Rocks, Sugar Loaf

The rocky summit ridge of Sugar Loaf is a pleasant bonus after the rather pedestrian approach, which tracks over bracken-strewn hills. This view to the west shows the mountain's western ridge leading down to the broad sweep of the Usk Valley. The peaks in the distance are Pen Cerrig-calch, with the Table at its feet, and Pen Allt-mawr.

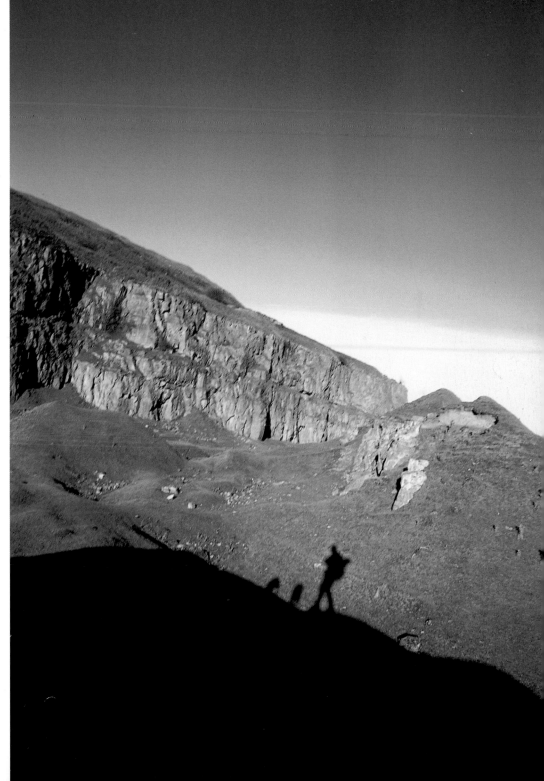

Shadows, Llangattock Escarpment
A spectacle that follows me on most on
my photographic forays; my own shadow
and those of my two dogs; Honey and India.
Taken beneath the limestone crags of
Mynydd Llangattock.

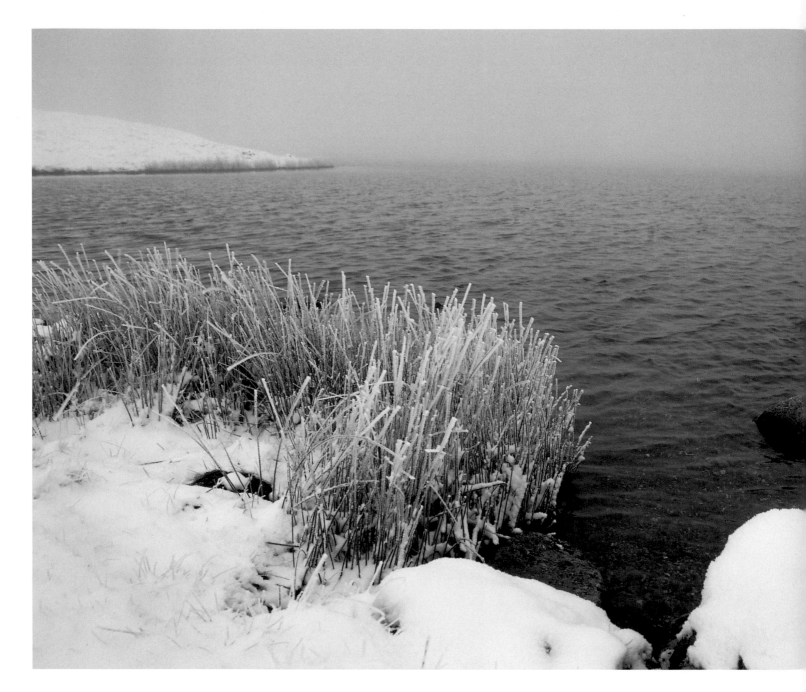

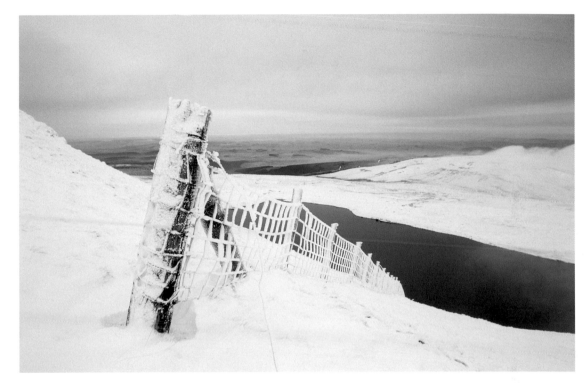

Above
Fence, Bwlch Giedd, Mynydd Ddu
This wire sheep-fence runs down to Llyn y Fan Fawr from Bwlch
Giedd. Normally not very attractive, it looks quite spectacular
when crusted in snow and ice.

Left
Llyn y Fan Fawr, Mynydd Ddu
I feel cold just looking at this picture. Frozen grass lines the grey
waters of the larger of the two Carmarthen Fan lakes.

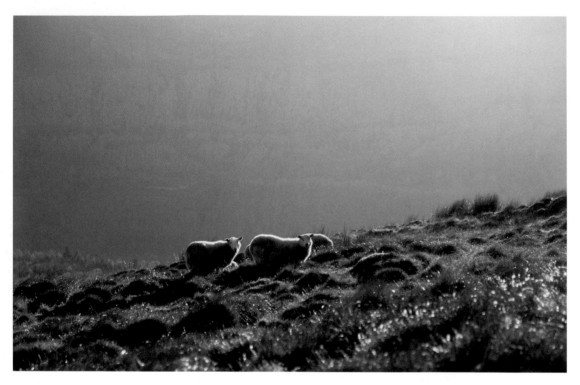

Above
Sheep, Allt Lwyd
The hardy Welsh mountain sheep have strong survival instincts.
They certainly cope incredibly well with the harsh winter weather.
This little group is grazing on the flanks of Allt Lwyd.

Right
Tor y Foel from Allt Lwyd
Mist hangs in the valleys, softening the outlines of the surrounding
peaks. As well as Tor y Foel, it is possible to make out Table Mountain
and the distinctive outline of Sugar Loaf, in the far distance.

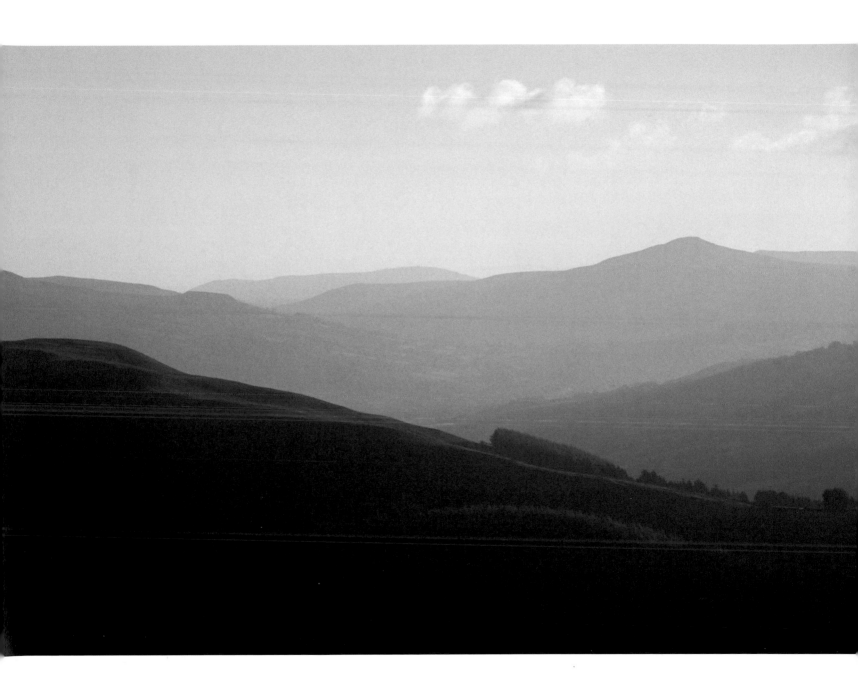

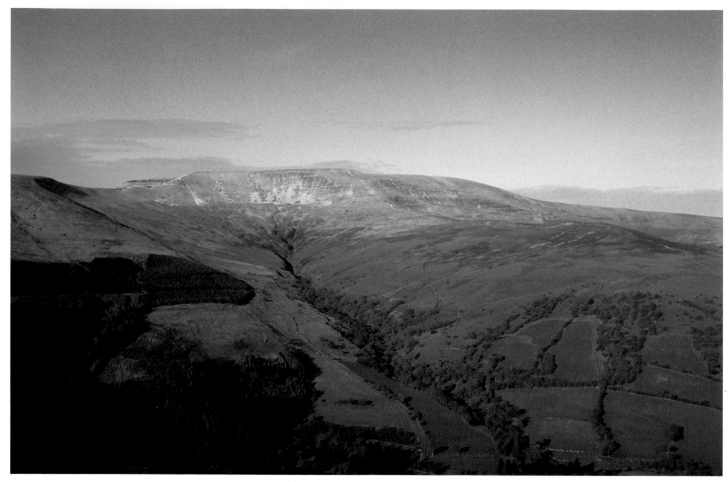

Cwm Nant Tarthwynni
This deeply-cloven wooded valley makes for a short but fine horseshoe walk
from the shores of the Talybont Reservoir. In this shot, the western-facing crags
of Craig y Fan are holding on to a faint dusting of snow.

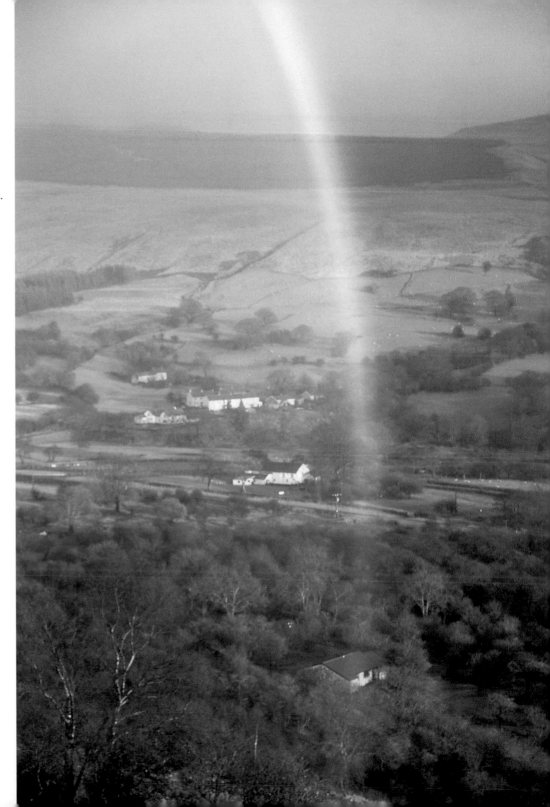

Rainbow over Glyntawe
A rainbow forms over Glyntawe in the Mynydd Ddu. It made a colourful and cheery companion as I sought shelter in the valley on a very stormy New Year's Eve.

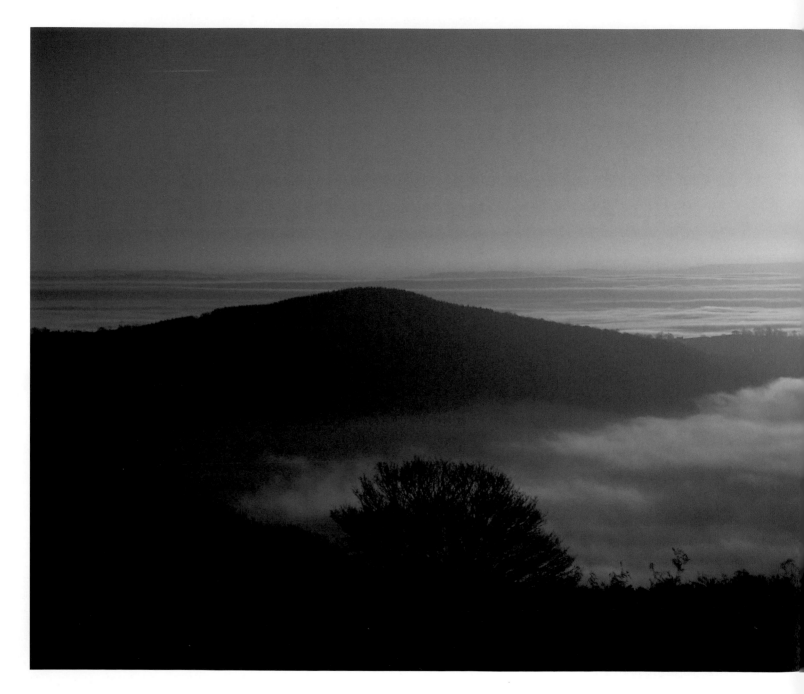

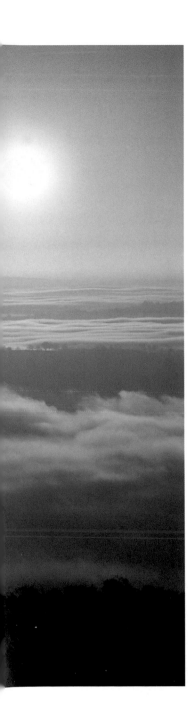

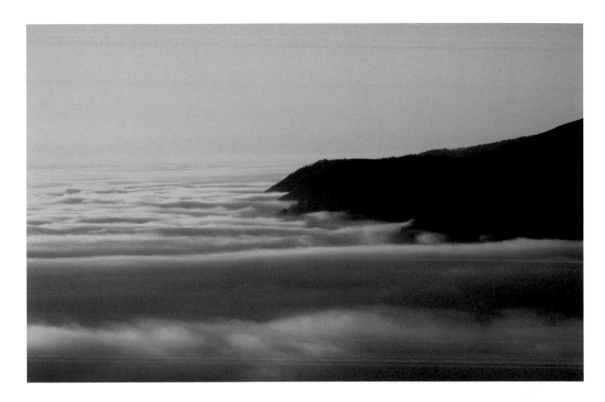

Above
Cloud inversion, The Blorenge
An ocean of early morning cloud washes up on the southern flanks
of The Blorenge, creating a scene which resembles a seascape.

Left
Sunset over Ysgyryd Fach
Looking east from Mynydd Llanwenarth, I was fortunate enough
to watch an amber sun rise over an almost-perfect cloud inversion.
The small wooded mound of Ysgyryd Fach pierces the gloom.

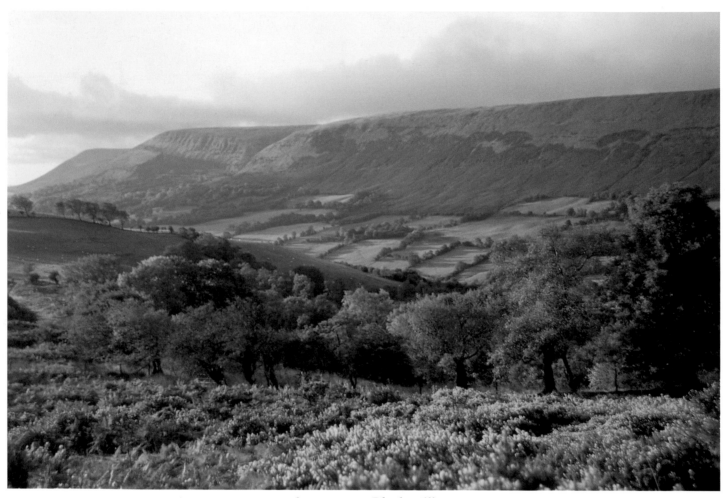

Autumn on Black Hill

The summer green gives way to the richer colours of autumn, although the foreground gorse ensures that the scene still appears very bright. It is incredible to think that in only a few weeks, there will hardly be a leaf to be seen anywhere.

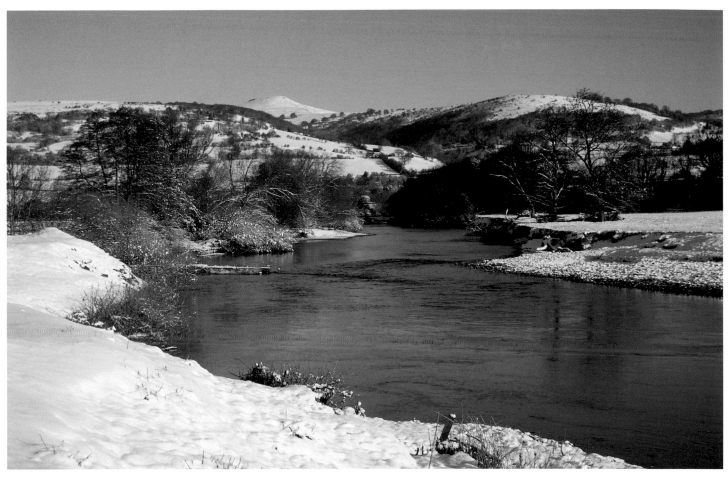

The River Usk, Near Abergavenny
The mighty Usk has a very placid feel to it by the time it reaches Abergavenny. It somehow
exudes a wise and calming influence on the mountainous landscape which surrounds it.
This shot looks upstream to the summit of Sugar Loaf.

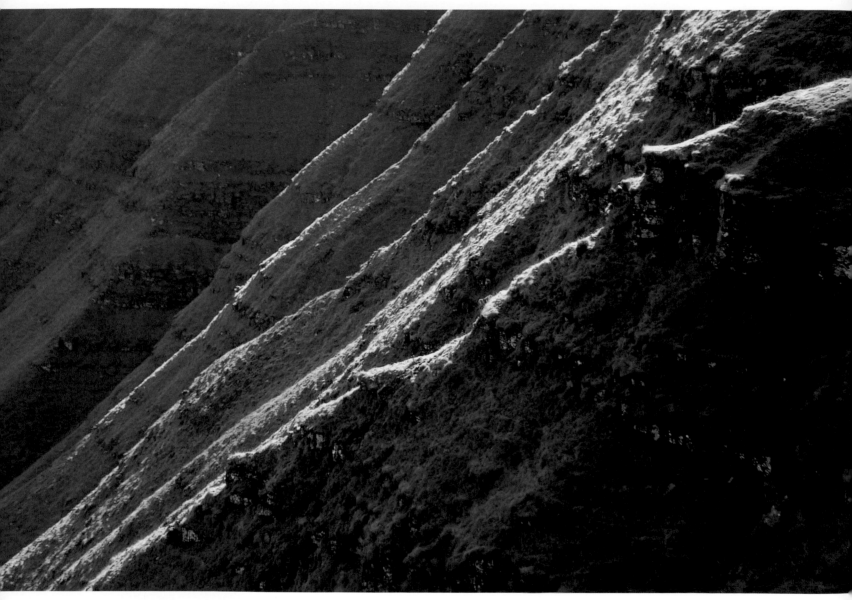

Pen y Fan from Cefn Cwm Llwch

This shot was taken from one of the most dramatic spots in the whole National Park. If you ever had any doubts that the Beacons were 'real' mountains, the view from this exposed position will certainly make up your mind.

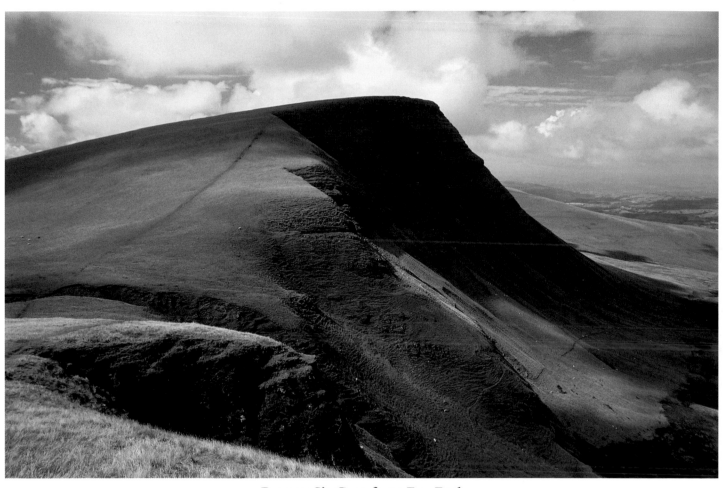

Bannau Sir Gaer from Fan Foel
The dramatic sweeping crags of Bannau Sir Gaer tower over the barren moors of the
Mynydd Ddu. This used to be very much a wilderness area, but in recent years the numbers
of walkers have created clear tracks like the one seen running up the east flank.

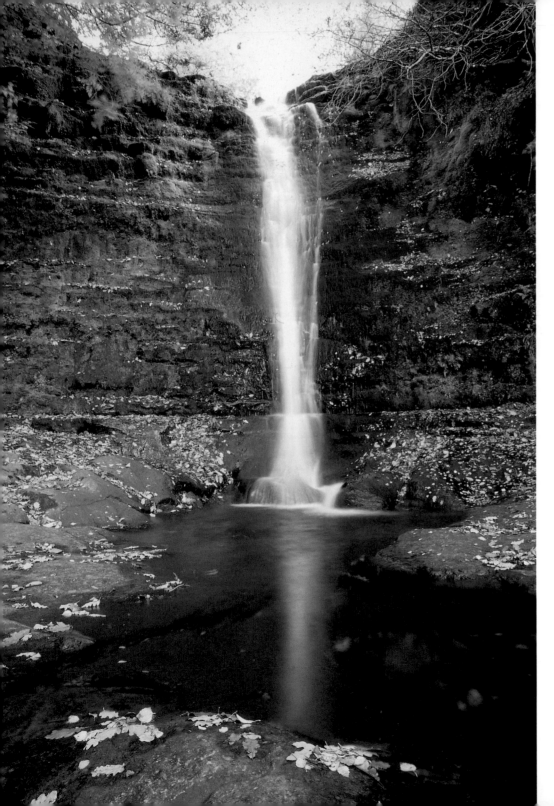

Waterfall, Afon Caerfanell
Over the years, I've seen this waterfall in just about every guise possible, from a completely frozen ice-climb to a raging torrent. Here it looks quite tranquil as it trickles over the 10 metre drop onto the smooth rocks below.

Trees, Gilwern Hill
A source of constant inspiration is this view
from my study window to the flanks of
Gilwern Hill. In autumn the trees provide
an ever-changing spectacle and in spring I
can watch the lambs playing while I work.

49

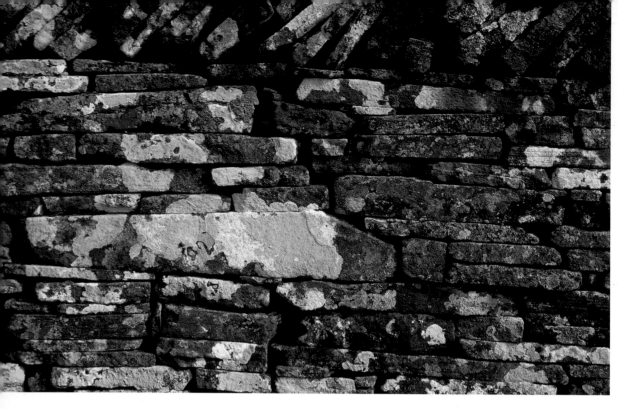

**Dry stone wall,
Allt yr Esgair**
The Old Red Sandstone
which makes up the backbone
of the Park also makes great
drystone walls. Different
lichens add a touch of colour.

**Moss covered wall,
Blaen y Glyn**
I was particularly taken with the
one round stone that breaks the
pattern of the others. A simple
shot but it took over an hour
to get it as the sun vanished
while I set my tripod up and I
was so sure that it was worth it,
I waited for it to reappear.

50

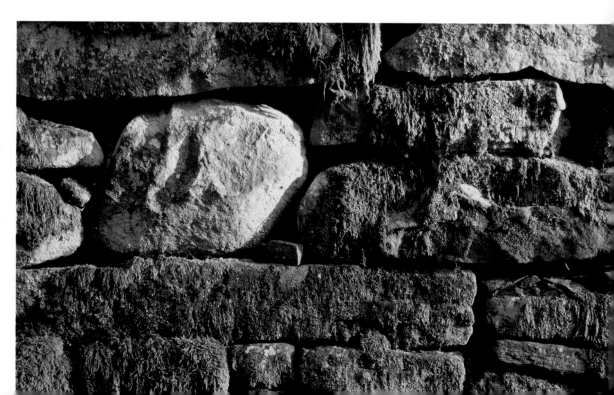

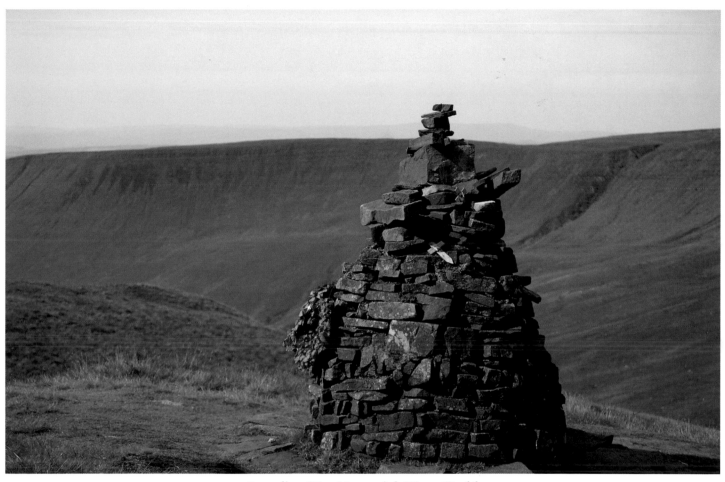

Canadian War Memorial, Waun Rydd

A touching tribute to the Canadian airmen who lost their lives during a training flight in the Second World War. Wreckage still litters the hillside where it came down in poor weather. It is a serene spot and a place I visit often. Among the many tributes I've seen my favourite was written on an ice-hockey puck.

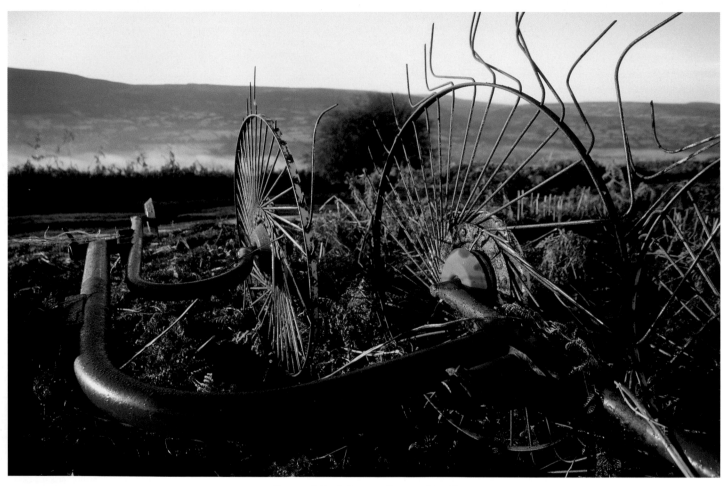

Farm Machinery, Sugar Loaf
Surrounded by so much natural beauty, it is sometimes easy to forget that this is also a
lived-in and working landscape. The early morning light enhances the rustic colours of this
farm machinery, enabling it to blend in perfectly with the bracken-covered hillside.

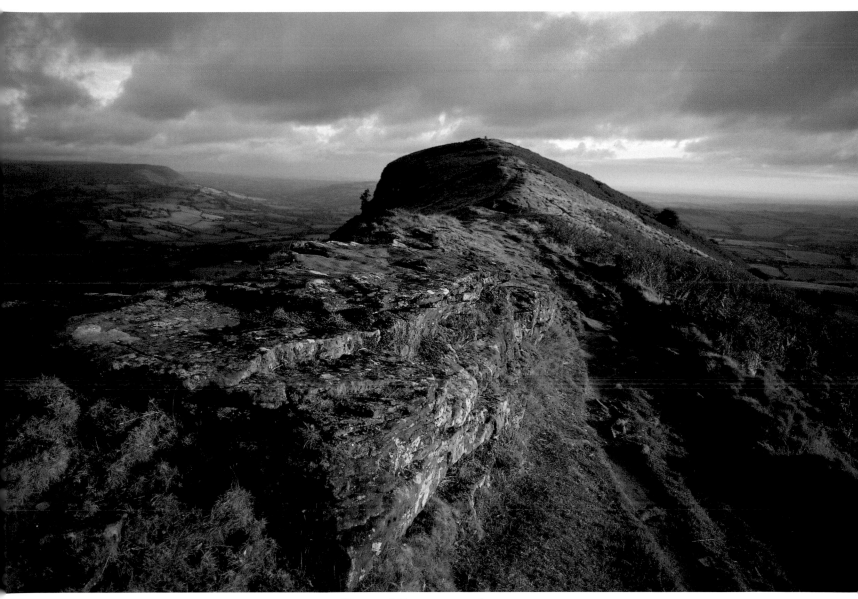

Ysgyryd Fawr at sunrise

The easternmost mountain in the National Park is a real gem with a narrow rocky spine which runs for over
a kilometre to the trig point. The clouds billowing across the Black Mountains really add atmosphere.

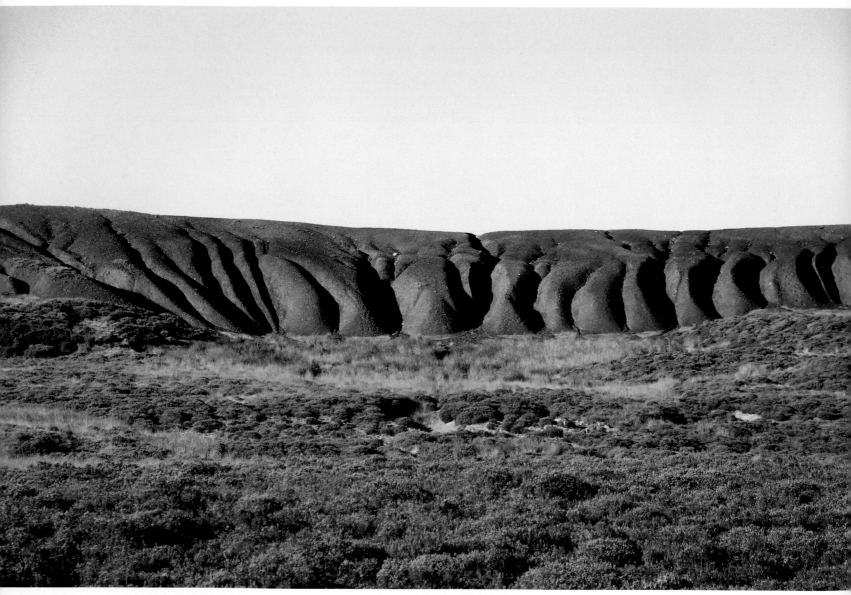

Mining Spoil, Blorenge

The Beacon's answer to Ayers Rock? Mining spoil on the flanks of The Blorenge marks the spot where the mountains of the National Park meet the industrial past of the South Wales valleys. The Blaenavon Iron Works and Big Pit Mining Museum are just a few minutes down the hill from here.

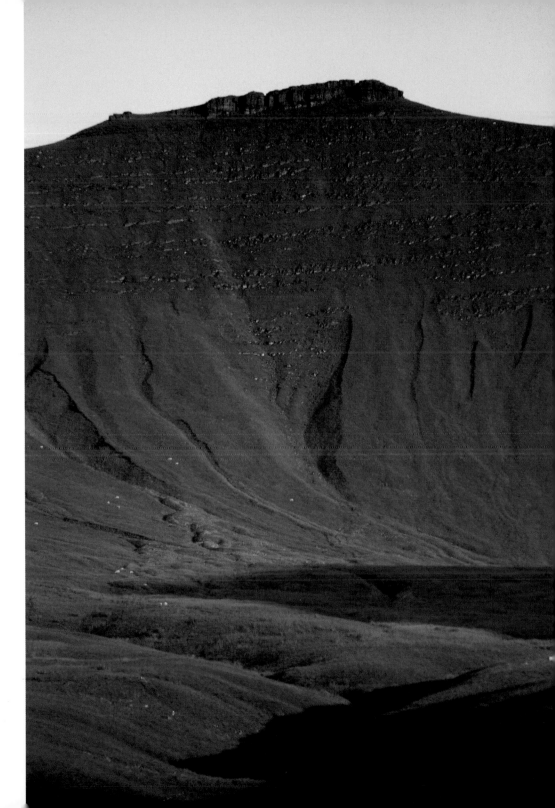

Corn Du
If you needed any reminding about
how big these mountains really are,
just stand beneath the precipitous
walls of Corn Du. The upper reaches
of the Nant Cwm Lwch are a
wonderfully quiet place to spend
a pleasant summer morning.

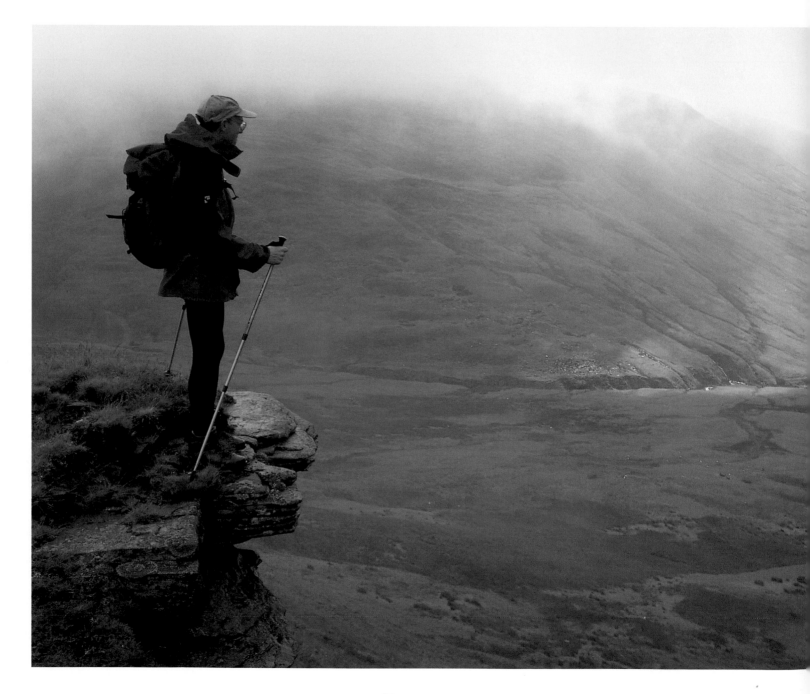

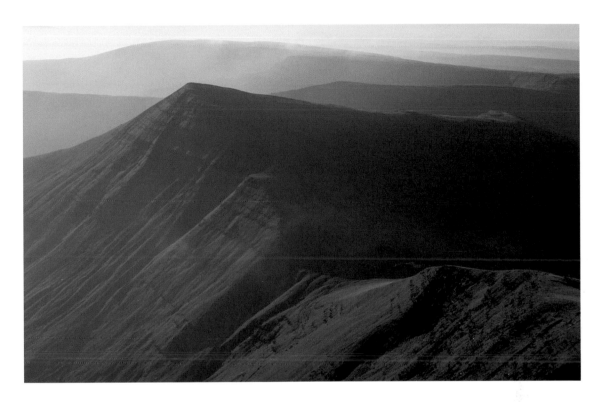

Above
Cribyn from Pen y Fan
A classic summer sunrise shot of Cribyn, taken from Pen y Fan.

Left
Clearing mist in the Caerfanell Valley
A walker stops on Craig y Fan Ddu to watch the mist clear from the
fertile plains of the Caerfanell Valley some 200m (650ft) below.
Beams of sunlight hint that the weather might improve.

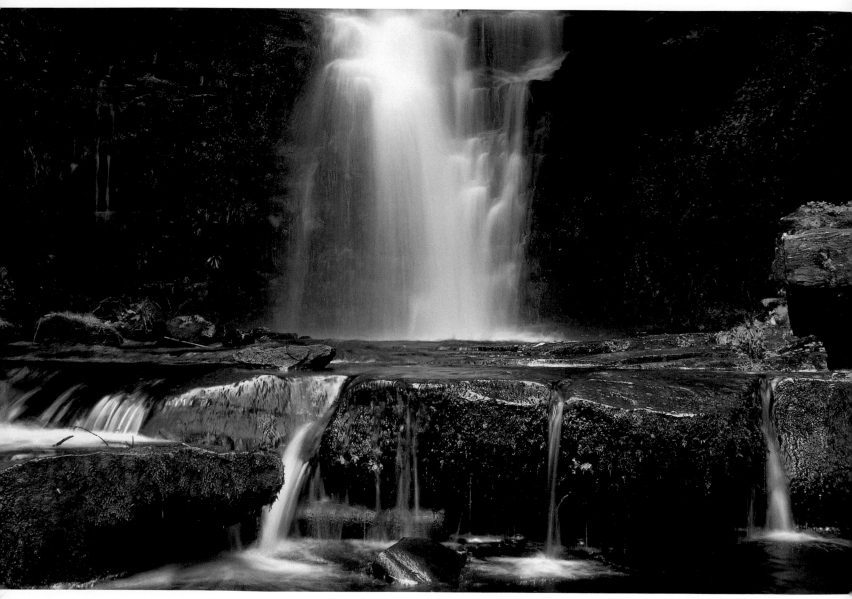

Waterfall, near Pont Blaen-y-Glyn
The woods between Pont Blaen-y-Gwyn and Torpantau, conceal some of the prettiest waterfalls in the area.
This one has an almost magical, fairy grotto, feel to it.

Stones and leaves near the Talybont Reservoir

As I dropped into the shade of a small copse, I was struck by the textures of these rocks, lit by a narrow beam of light. Although they were dry when I took the picture, I suspect they would make a stream bed during wetter months.

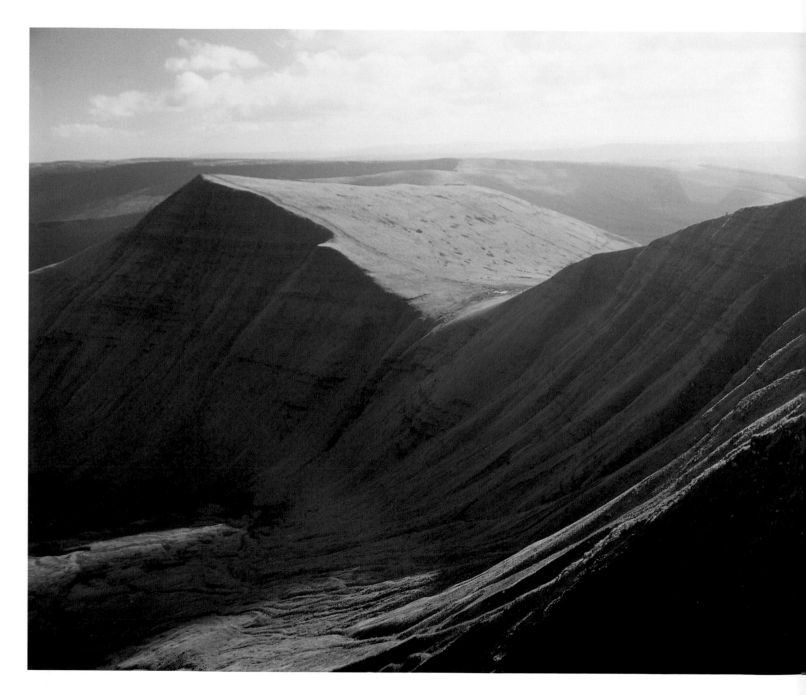

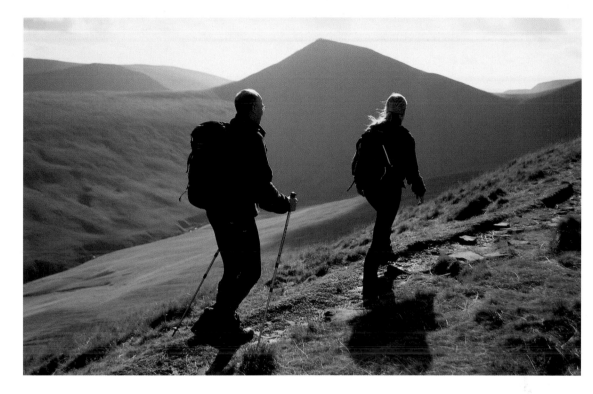

Above

Walkers, Cefn Cwm Llwch

Silhouetted against a low winter sun and the dark north face of Cribyn, these two
walkers are making steady progress up towards the summit of Pen y Fan.

Left

Cribyn from Pen y Fan

Looking across the precipitous north-east face of Pen y Fan to the shapely summit of
Cribyn. Amazingly, a track traverses the steep escarpment of Cribyn, leaving the saddle in
the centre of the shot and trending leftwards across ground that looks impossibly steep.

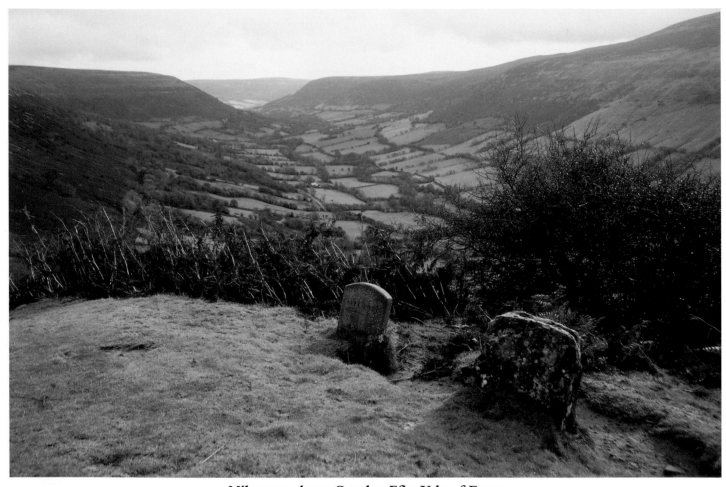

Milestone above Capel-y-Ffin, Vale of Ewyas

Looking down the Vale of Ewyas from the hillside above Capel-y-Ffin. The larger boundary stone looks like it has seen a few more winters than the modern one showing the route down.

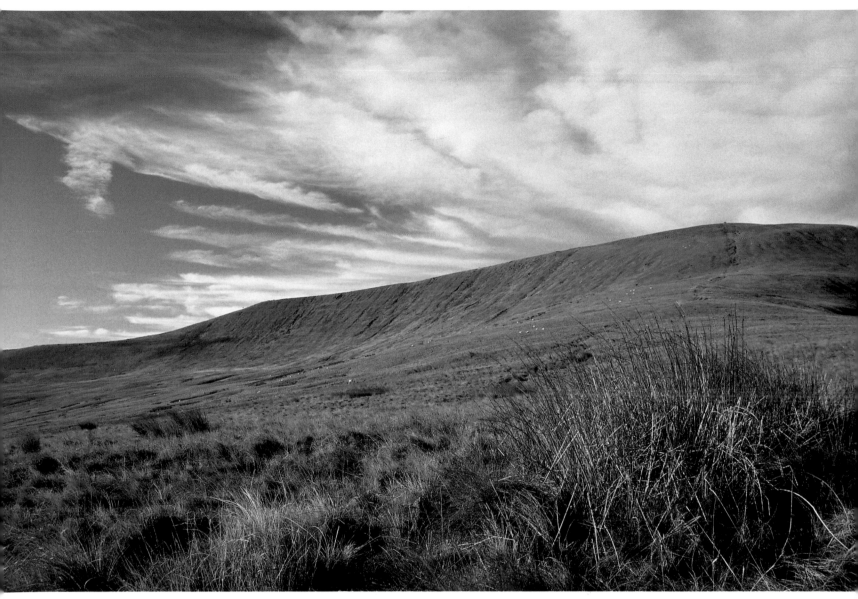

Craig y Fan and Waun Rydd from Twyn Du

Who said that blue and green should never be seen? The contrasting colours of sky and foreground plus the wonderful cloud formations spilling over the high moorland plateau, make for a captivating image of a fairly featureless landscape. A keen eye will spot the giant cairn of Carn Pica on the horizon.

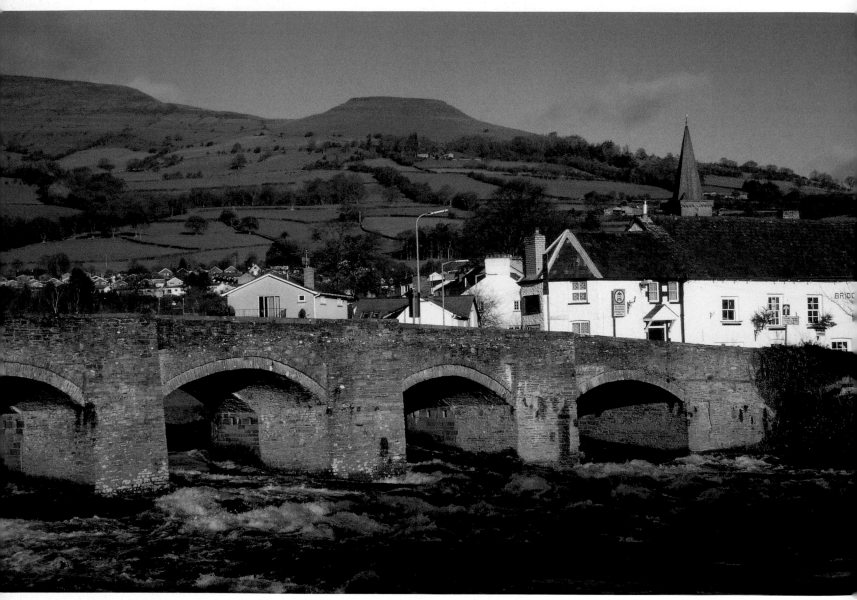

Bridge over the River Usk, Crickhowell
A fairly turbulent River Usk gushes out from beneath the main bridge in
Crickhowell. Table Mountain (Crug Hywel in Welsh), towers above.

High Street, Abergavenny
The eastern gateway to the National
Park and a delightfully busy little market
town that lies at the feet of some wonderful
mountains. This view along the bustling
High Street shows just how close
the high ground is.

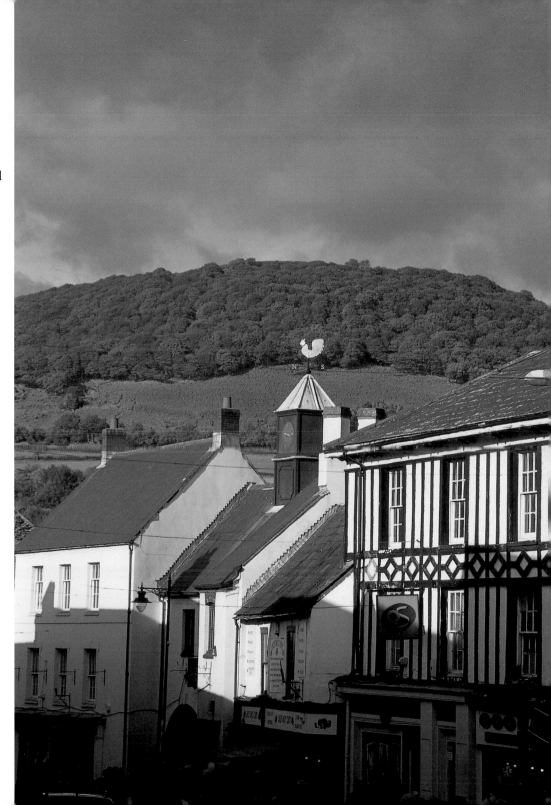

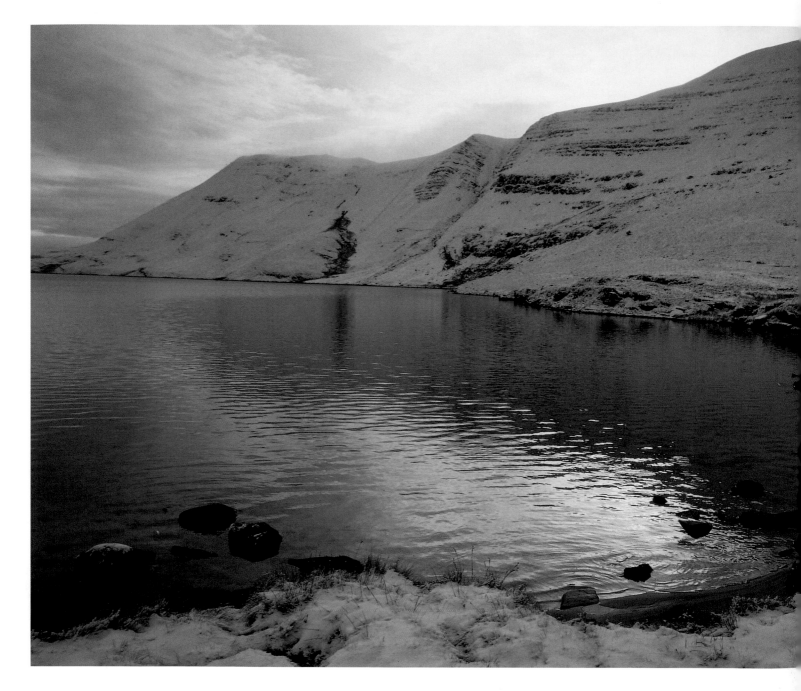

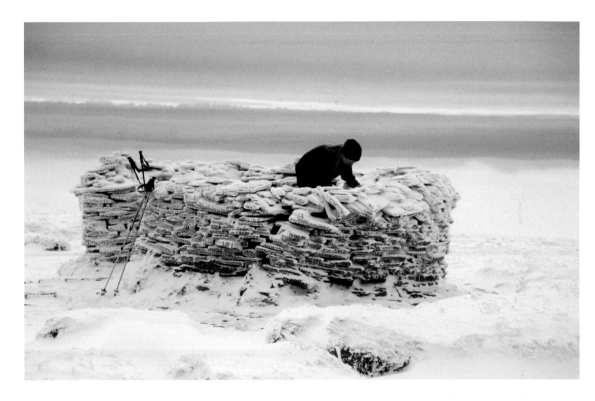

Above

Summit shelter, Bannau Brycheiniog

This small circular windbreak, on the highest point of the Mynydd Ddu, is always a welcome sight after the long climb up. It doesn't make much of a picture on its own, but the addition of winter conditions and a walker making the most of the shelter really does add to the atmosphere.

Left

Llyn y Fan Fawr

With no decent track leading to it or no legend to draw the crowds, this lake maintains a more tranquil disposition than its smaller twin. There is great solitude here beneath the sweeping escarpment of Fan Hir.

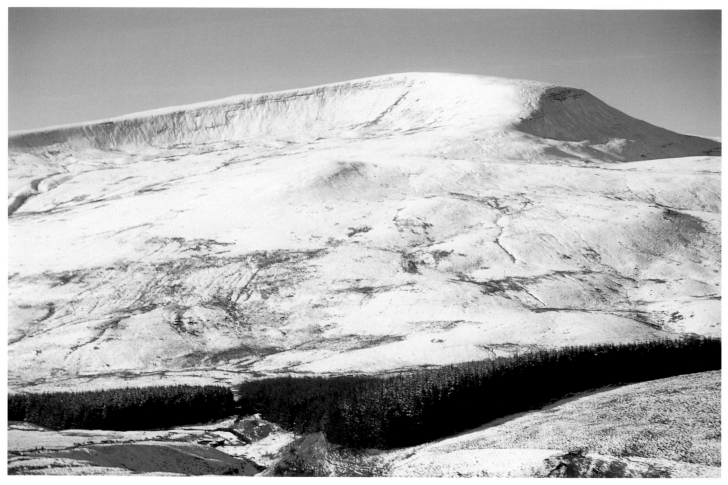

Fan Fawr from Corn Du

The majestic escarpment of Fan Fawr as viewed from the flanks of Corn Du. The A470 is hidden beneath the swathe of coniferous woodland which sweeps across the bottom of the picture.

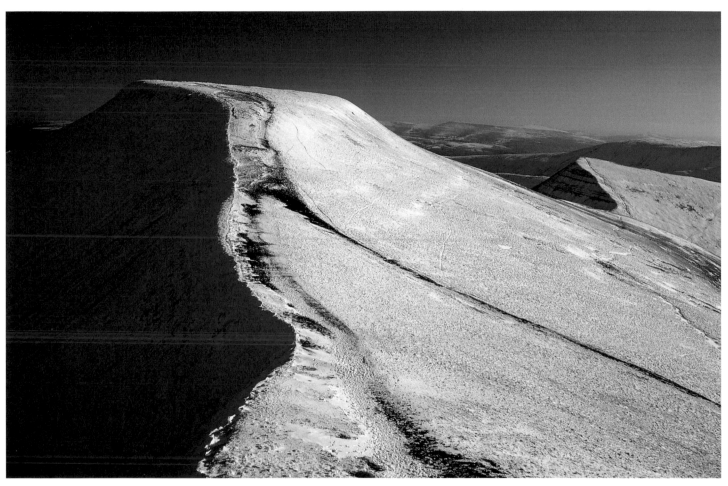

Pen y Fan from Corn Du
One of my favourite shots of Pen y Fan showing it in all its winter glory just after sunrise on a fine March morning.
I once tried to stay up here for whole day in these conditions so I could make the most of the morning and the
evening light at the same time. Eventually the cold got the better of me. Next time I'll try camping!

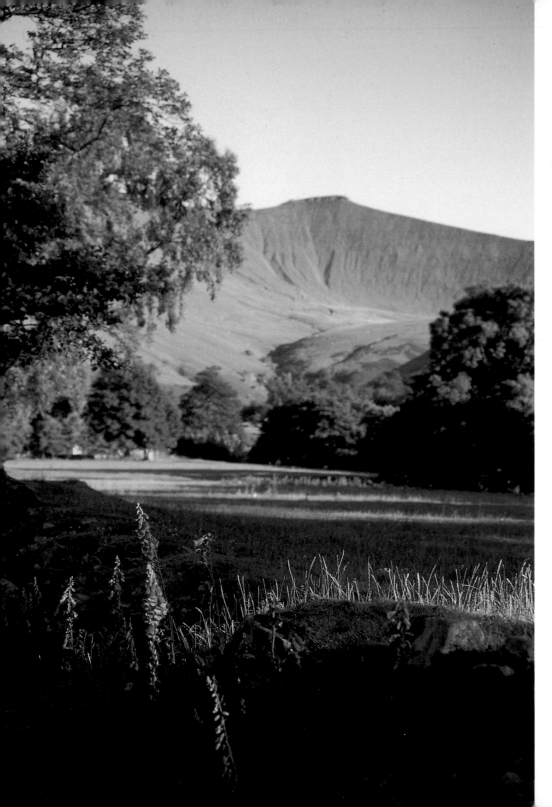

Corn Du from Cwm Llwch
The impressive bulk of Corn Du presides over the fertile meadows of Cwm Llwch. When seen like this in mid July, it is difficult to imagine how hostile it can be in the depths of winter.

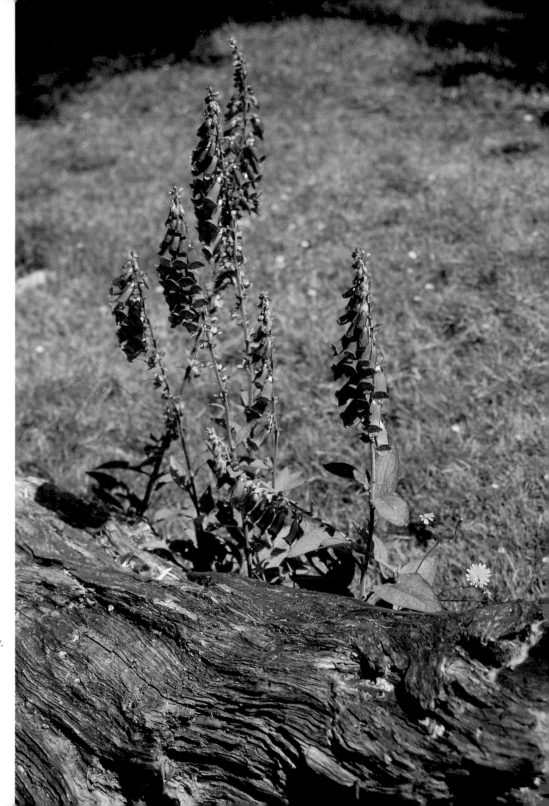

Foxgloves, Cwm Llwch
While I'm more usually found turning
my lenses to the mountains, I also adore
warm sunny afternoons in the valleys below.
These foxgloves were growing next to an
old fallen tree, close to the car park at
the bottom of Cwm Llwch.

71

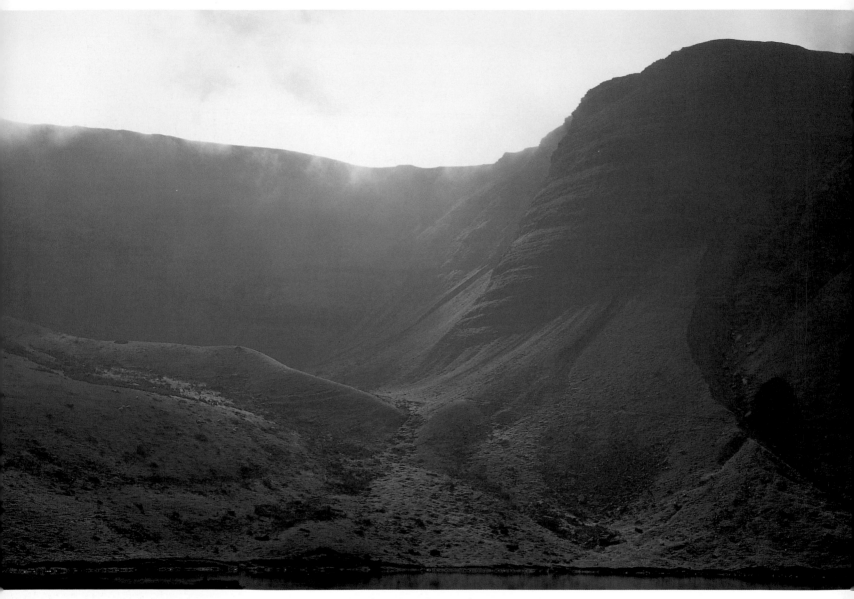

Bannau Sir Gaer from Llyn y Fan Fach

Mist lingers in the huge hanging valley which is cradled between Bannau Sir Gaer and Fan Foel.
The lake in the foreground is Llyn y Fan Fach – the 'Magic Lake'

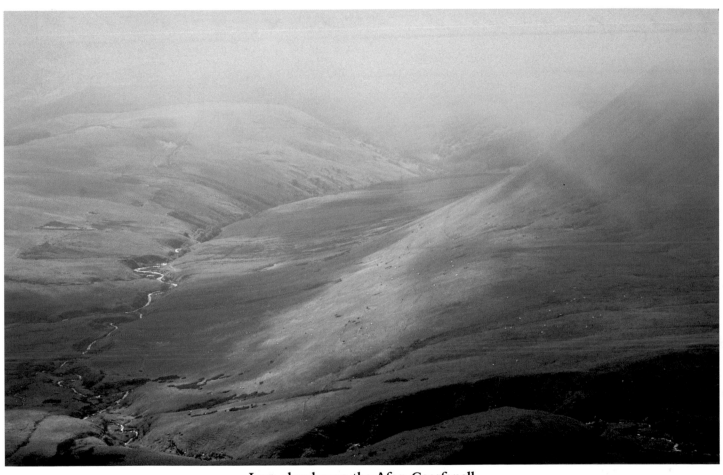

Low cloud over the Afon Caerfanell
The cloud lifts enough to reveal the shimmering ribbon of the Afon Caerfanell.
The shot was taken from high on Craig y Fan Du.

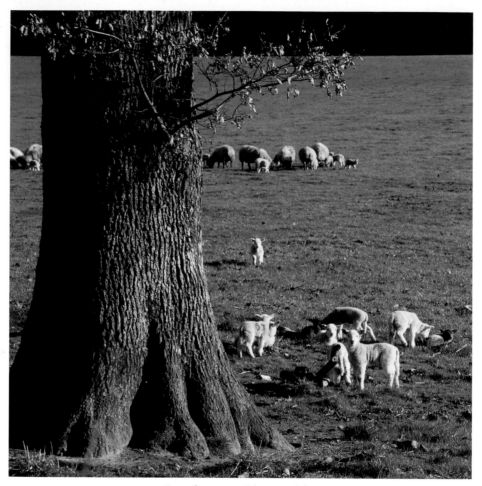

Lambs near Llangynidr

John Muir may have described them as 'hooved locusts', but mountain
sheep are very much a part of the Welsh hills.

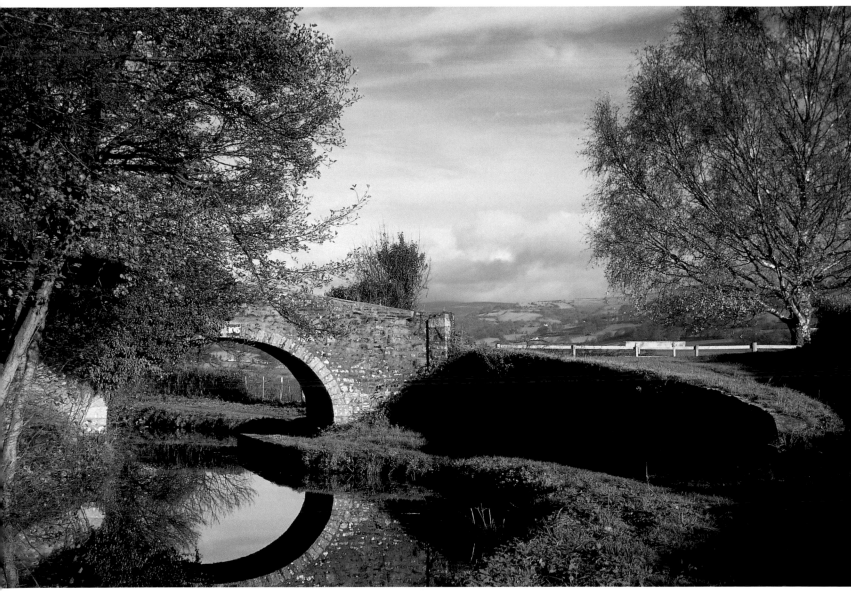

Bridge, Brecon and Monmouthshire Canal near Gilwern
This is a magical spot with great views across the River Usk into the very heart of the Black Mountains.

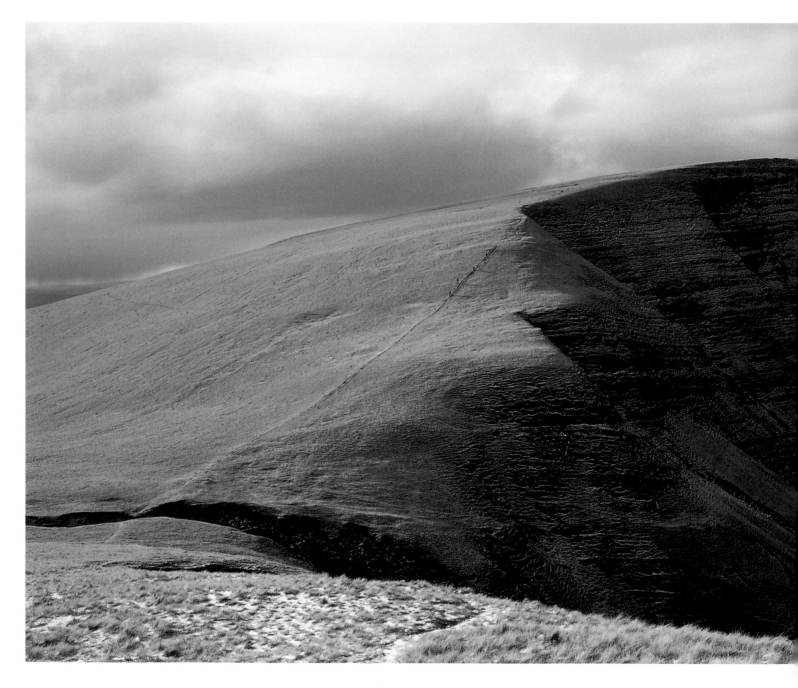

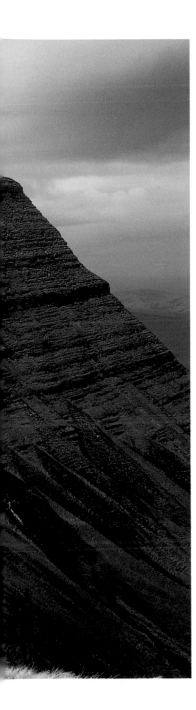

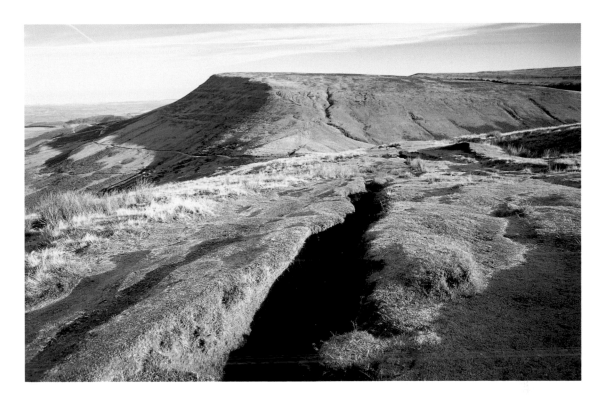

Above
Footpath Erosion, Twmpa
Footpath erosion is a huge problem in the National Park, as this deep trench above the Gospel
Pass demonstrates. Peak watchers will recognise the distinctive form of Hay Bluff behind.

Left
Bannau Sir Gaer, Mynydd Ddu
Bold and iconic, the impressive profile of Bannau Sir Gaer is everything a mountain should be.
The ant-like walkers approaching the summit give the scene a real sense of scale.

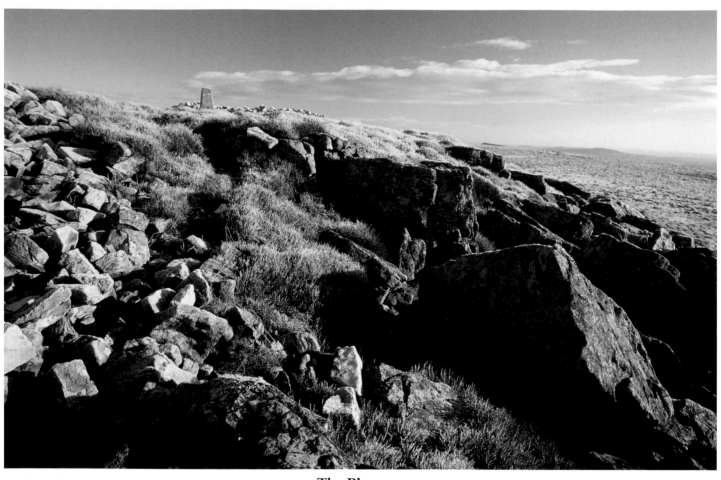

The Blorenge

Bleak and barren at the best of times, The Blorenge takes on an even more hostile demeanour in a heavy frost.
This picture was taken early one February morning when the outside temperature was minus 8°C.

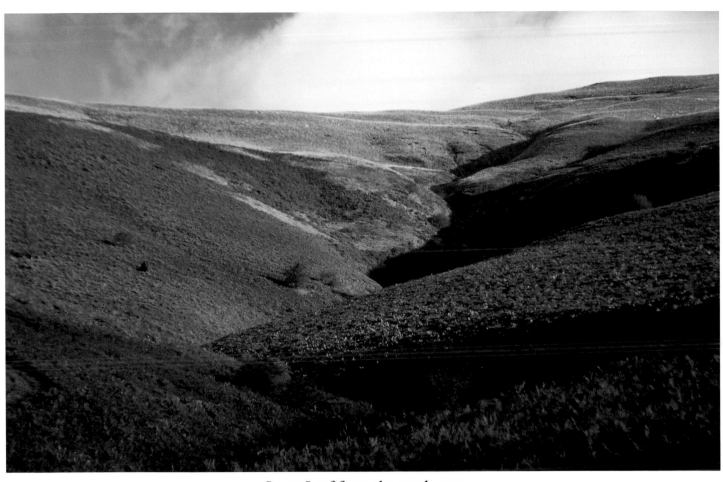

Sugar Loaf from the south west

I was taken by the wavy line of the small valley which snakes down from the summit. The brook it carries is unnamed on the OS map, but drains into the Afon Grwyne Fawr just a short distance downstream.

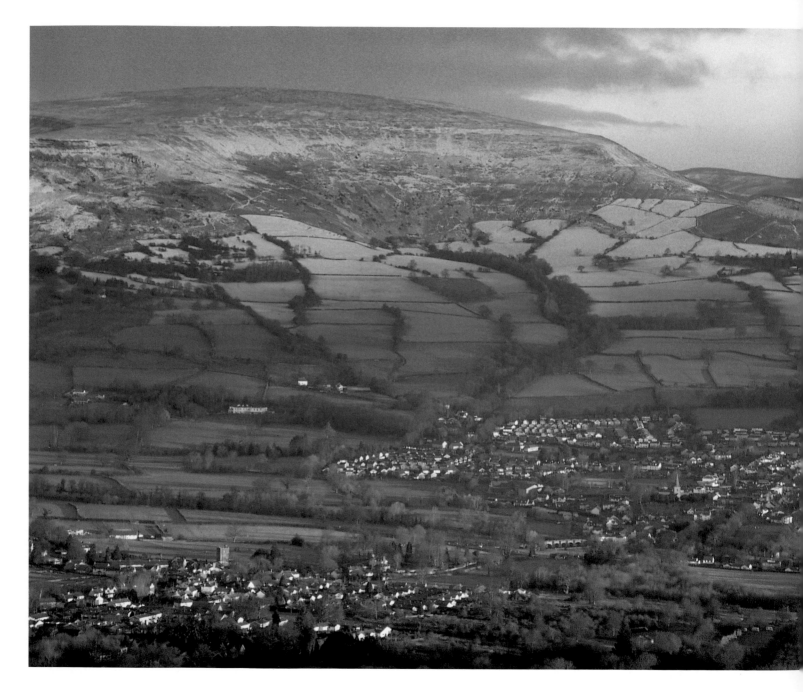

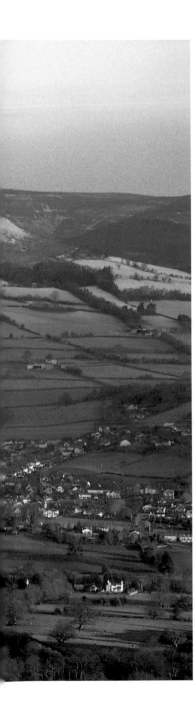

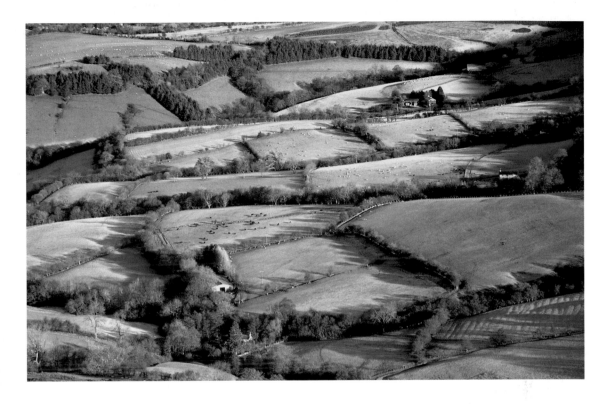

Above
Field Patterns near Hay-on-Wye
Patchwork field patterns are always good to photograph, but they become
even more distinctive when there's some frost about as it tends to linger in the
shade of the hedges, adding an extra dimension to the whole scene.

Left
Crickhowell from Mynydd Llangattock
Crickhowell and Llangattock village lie beneath the impressive bulk of Pen Cerrig-calch.
Taken from Mynydd Llangattock, this shot really shows the breadth of the Usk Valley.

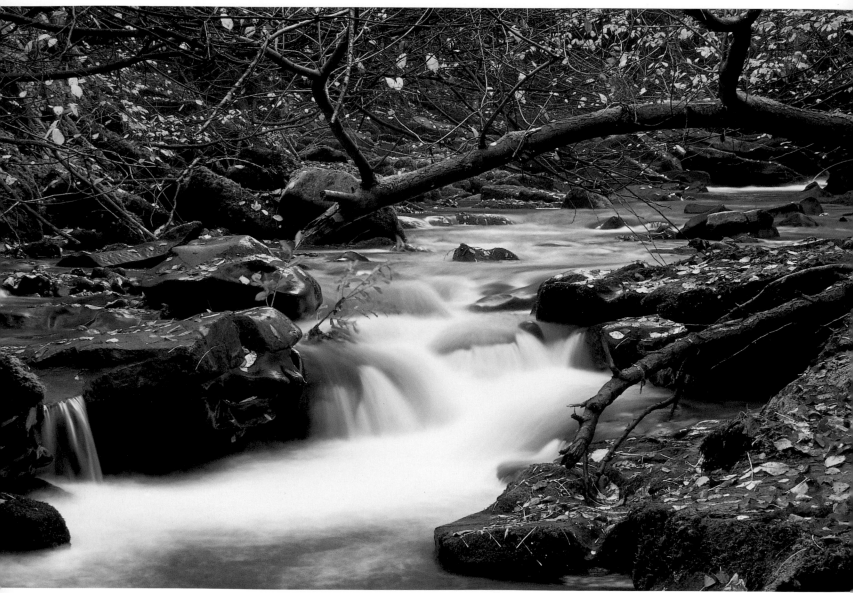

Cascades in the Clydach Gorge

The Clydach Gorge is an incredible place, despite the fact that the Heads of the Valleys Road runs right through the middle of it. It is amazing to think of all the people who use the road yet have no idea at all that this beautiful river runs just a few metres away.

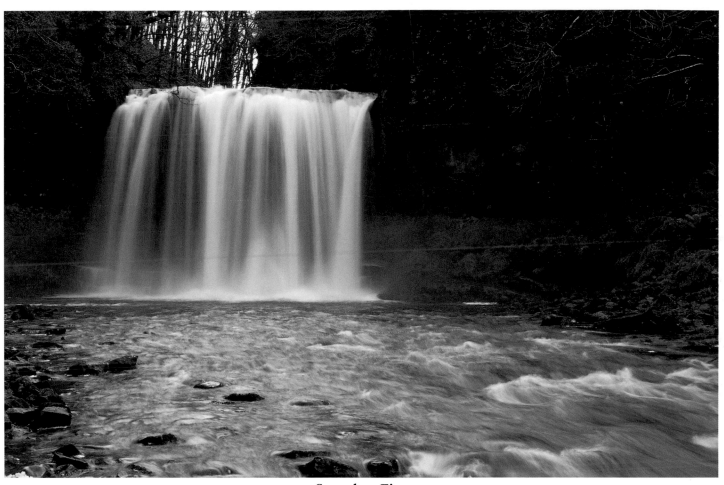

Sgwyd yr Eira

Sgwyd yr Eira is famous as the waterfall that you can walk behind, and this shot shows the beauty of the cascade from a distance. The name, rather poetically, means 'Falls of Snow'.

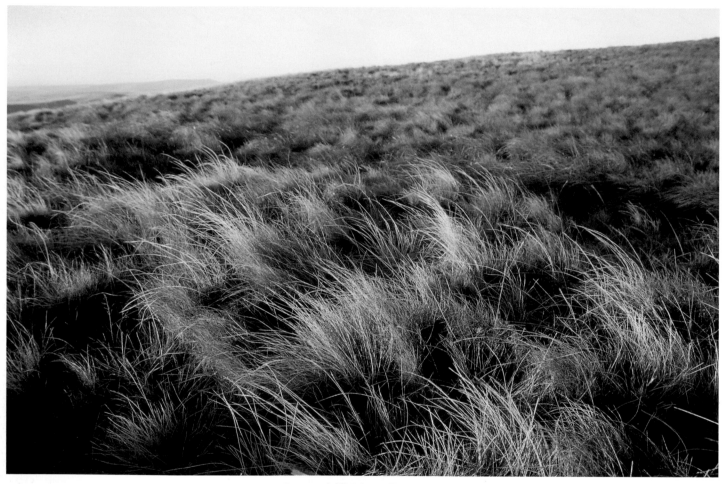

Grassy hillside, Allt Llwyd
Much of the National Park comprises featureless moorland which doesn't really make
for exciting images, but it does have an appeal all of its own. This shot was taken at
sunrise looking towards the central Brecon Beacons from the flanks of Allt Llwyd.

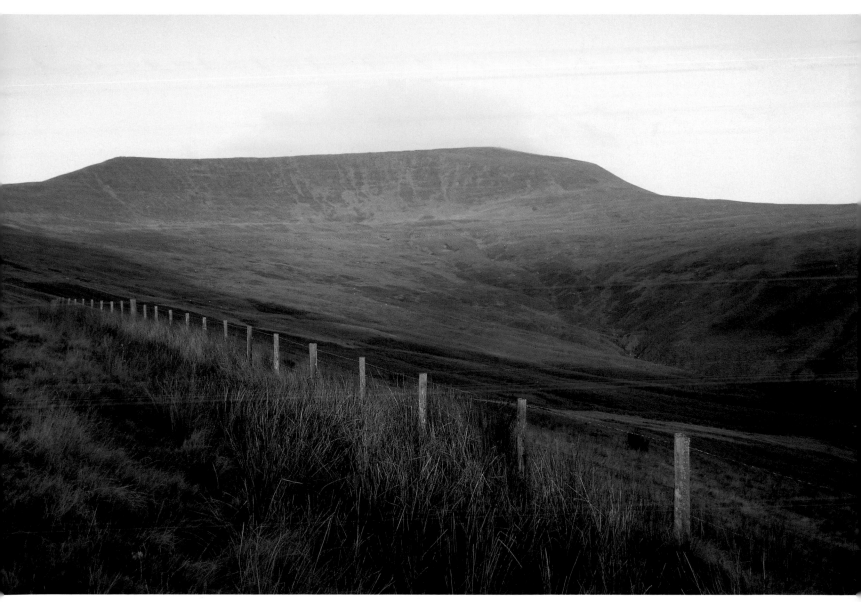

Waun Rydd from the flanks of Allt Lwyd

An old sheep fence provides a perfect lead-in to this sunrise shot of the craggy east face of Waun Rydd. The hillsides of the Beacons can be very featureless at times, so the photographer has to make the most of any potential foregrounds.

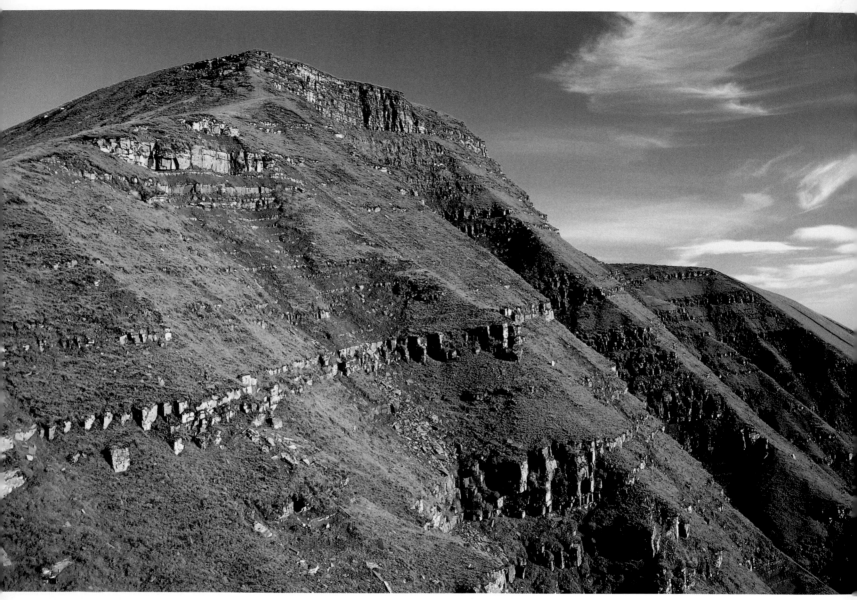

Pen y Fan

The cloudless blue sky and deep green grass of mid summer give the formidable
north-east face of Pen y Fan a far friendlier demeanour than it usually exhibits.

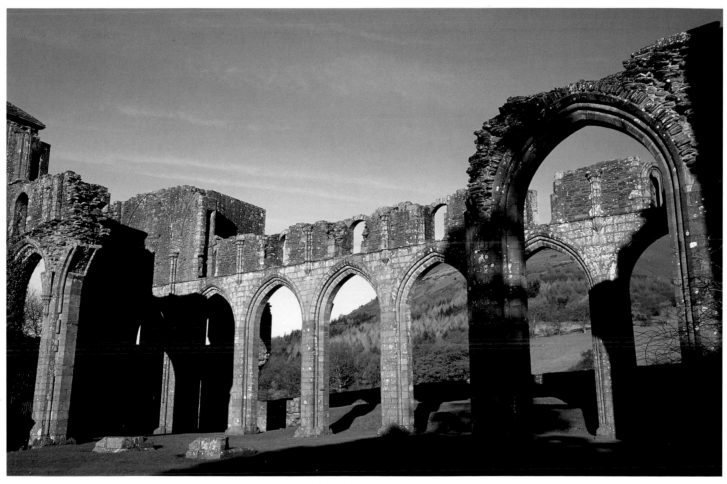

Llanthony Priory.
Much loved by artists including, most famously, J. M. W. Turner, the ruins of the twelfth-century Llanthony Priory are incredibly atmospheric. It is not an easy building to photograph, but I was rather pleased with this shot as I think it captures the grandeur of the arches while still showing the proximity of the beautiful mountains.

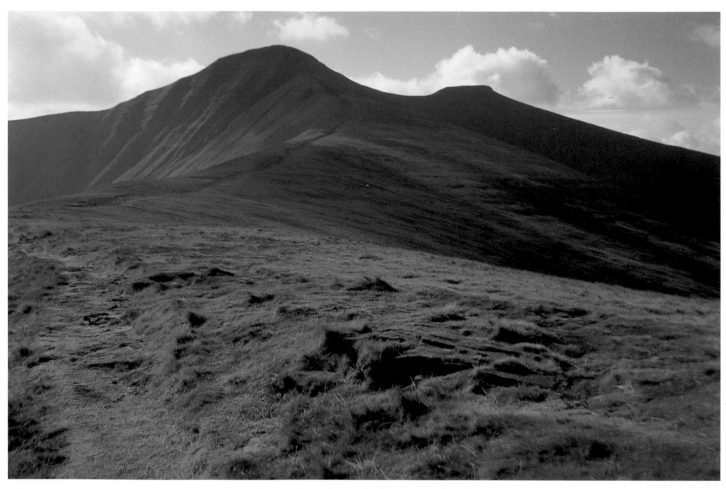

Pen y Fan from Cefn Cwm Llwch

This is my favourite way to approach or descend Pen y Fan as I love the sight
of the two high peaks towering above the deeply-cloven valley of Cwm Llwch.
In my view this route provides the best high mountain day in the Park.

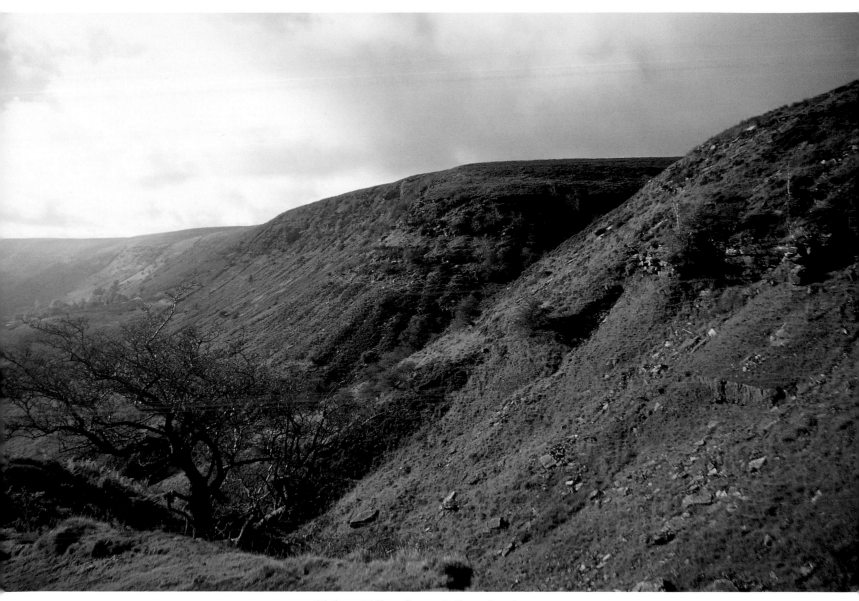

Olchon Valley from Crib y Garth
The upper reaches of the Olchon Valley are steep, craggy and wonderfully remote.
This image looks down the valley from near the top.

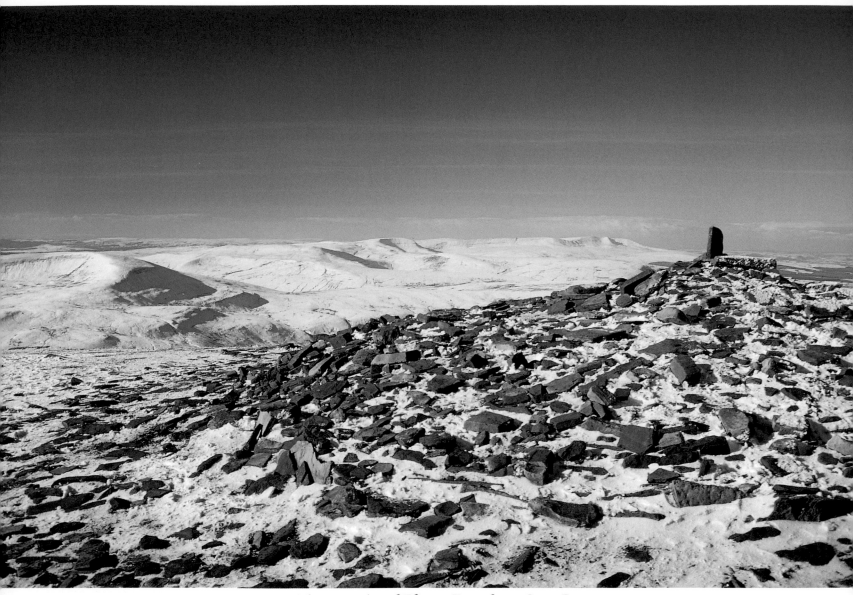

The summits of Fforest Fawr from Corn Du
The phrase 'the summits go on forever' is much used but seldom true. But in this shot, taken from the summit of Corn Du, they certainly do. In order of appearance the peaks are Fan Fawr, Fan Llia and Fan Dringarth, Fan Nedd, the obvious cirque of Fan Gyhirych, Fan Hir and Fan Brycheiniog. In total these mountains span over 20km (12 miles).

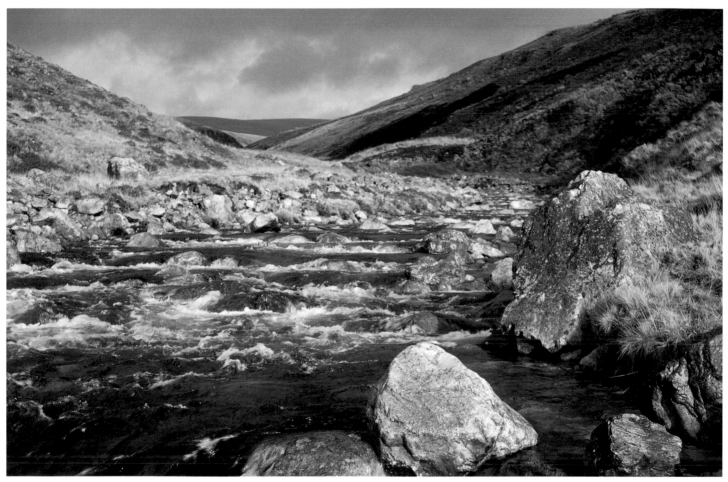

Afon Twrch, Mynydd Ddu

The Afon Twrch; a magical river mentioned in *The Mabinogion* – Arthur is said to have chased a mythical boar along its banks. In spate it is one of the most formidable rivers in the region.

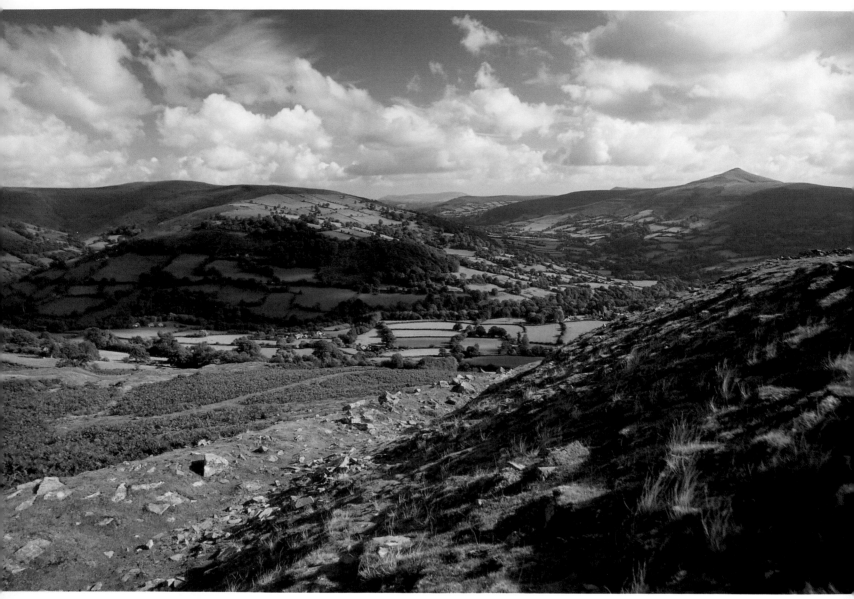

Crug Hywell, Table Mountain

The rocky ramparts of the Crug Hywell, the Iron Age hillfort that sits atop the distinctive knoll of Table Mountain. The middle distance is filled by the grassy slopes of Crug Mawr while the conical peak in the distance is, of course, the Sugar Loaf.

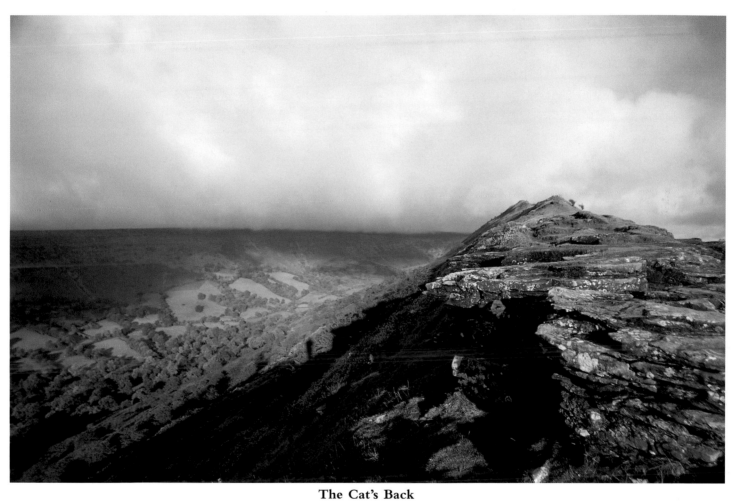

The Cat's Back
Looking north along the Cat's Back with the beautiful Olchon Valley to the left.
Note the low cloud shrouding the Hatterall Ridge and Hay Bluff.

Hilltop grass, Pen Cerrig-calch

The limestone summit of Pen Cerrig-calch feels very different to most of the sandstone tops in the Park. It glows brightly, almost blue, in stormy light and is very barren and tundra-like on top.

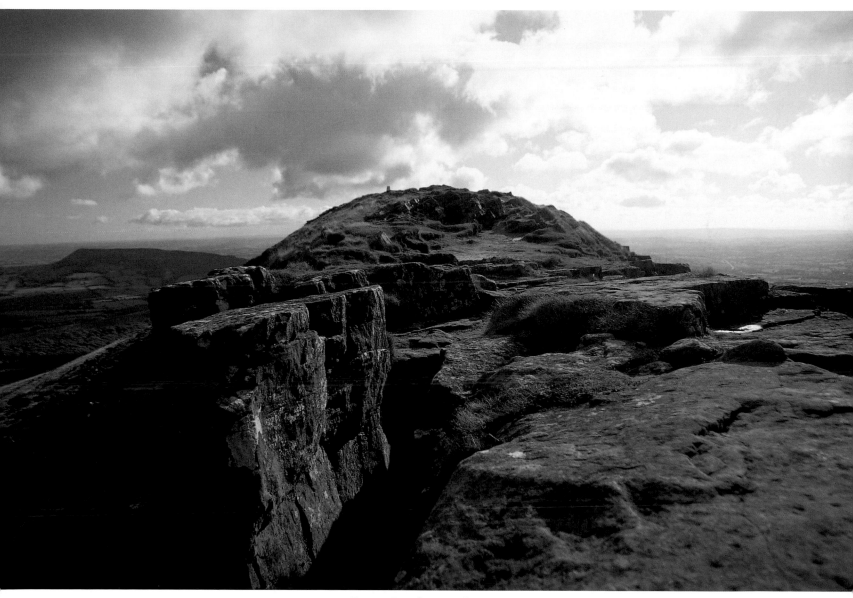

Sugar Loaf summit
A welcome sight after a long climb, the slender summit of Sugar Loaf beckons.
The mountain to the left is another of the Abergavenny peaks: Ysgyryd Fawr.

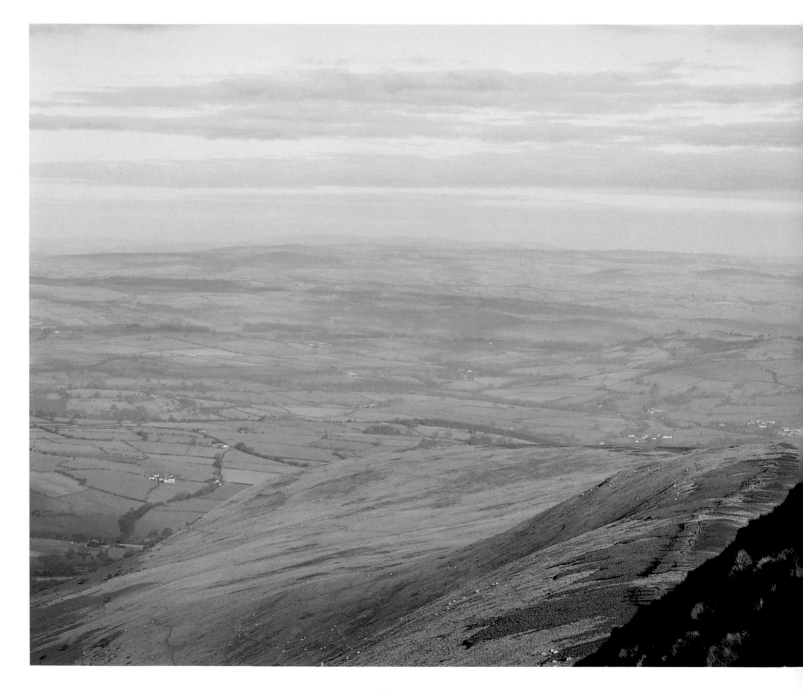

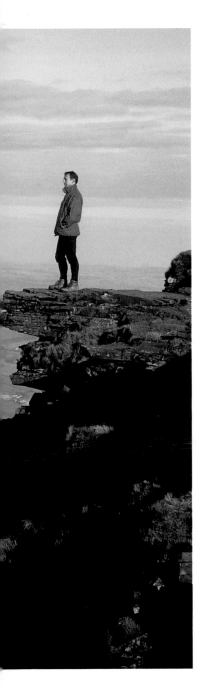

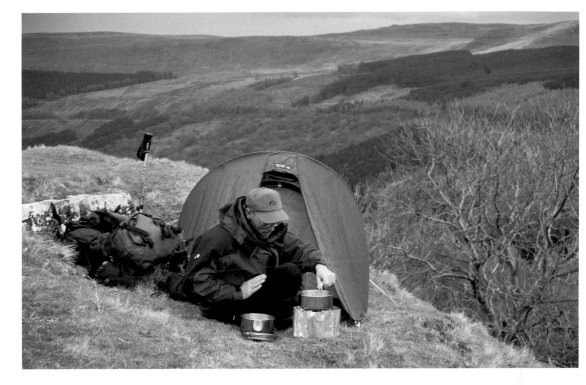

Above
Camping, Craig y Fan Ddu
The best way to appreciate the beauty of the area is to spend a
night high up in the hills. This shot was taken on day two
of a four-day trek across the whole National Park.

Left
The Diving Board, Cribyn
Although there are many similar protruding sandstone slabs
scattered around the Park, this one, near the summit of
Fan y Big, is probably the best known.

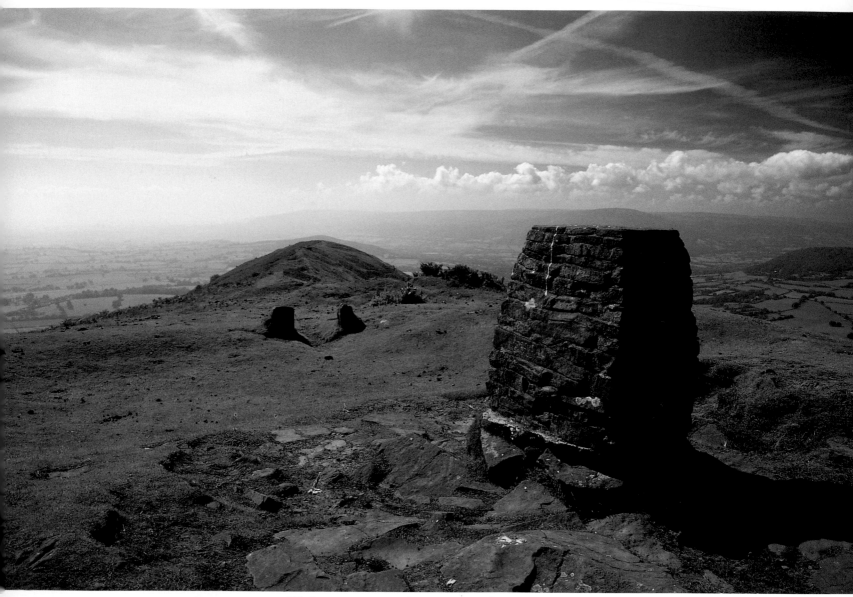

High summer on the summit of Ysgyryd Fawr.
Taken from the trig point, this picture shows the slender ridge stretching out in the distance. The two small standing stones, in the centre of the frame, mark the doorway to a small chapel which once stood on the summit.

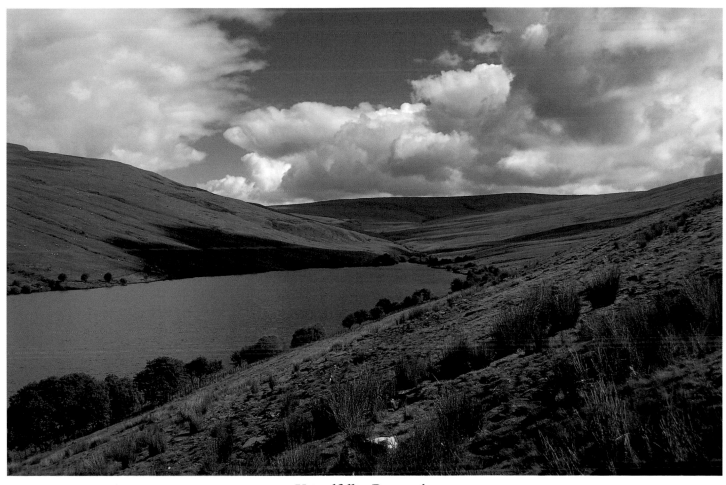

Ystradfellte Reservoir
Storm clouds gather over the Ystradfellte Reservoir, deep in the heart of Fforest Fawr. If the crowds
of the central Beacons ever become too much, this valley will offer sanctuary.

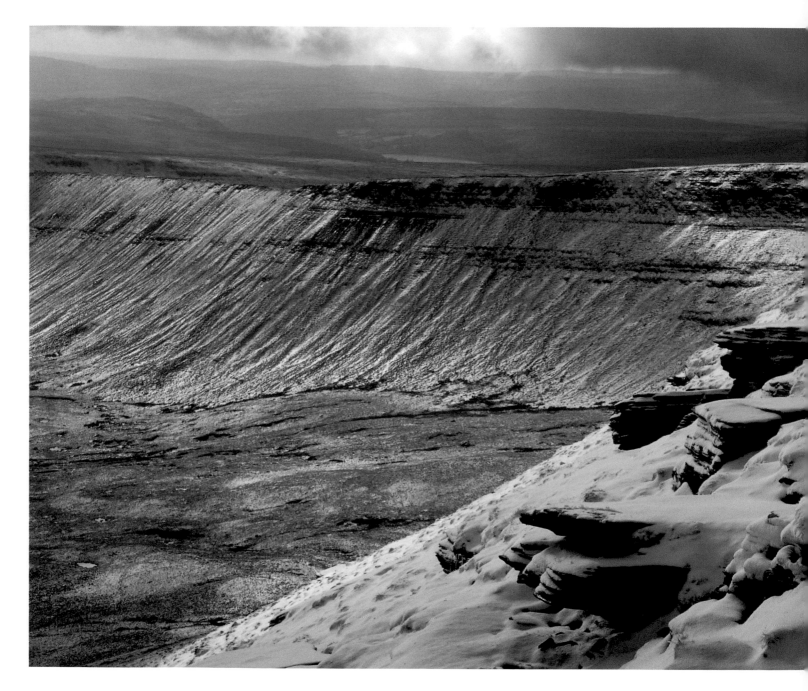

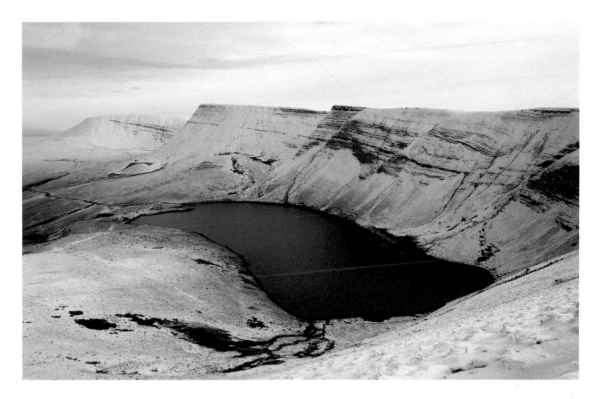

Above
The Carmarthen Fan from above Llyn y Fan Fach
Looking east across Llyn y Fan Fach. An almost identical shot to p140
but taken in full winter raiment, showing just how the moods of the
mountains really do alter with the seasons and the weather.

Left
Craig Gwaun Taff from Corn Du
Stormy light really paints an atmospheric picture on the snow-covered slopes of Craig Gwaun Taf.
I spent a good few hours in the hills on this particular day, but the low cloud and constant snow
storms made sure that I only managed a couple of decent exposures, and this was the best.

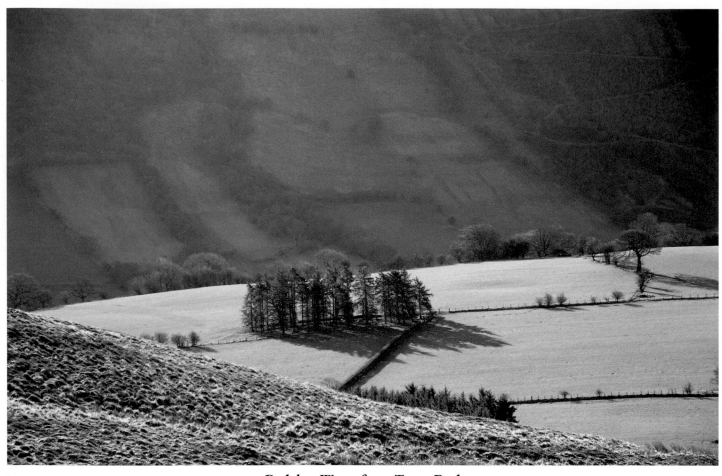

Bwlch y Waun from Tor y Foel

My attention was caught by the contrast of the lush green field against the tussocky hillside in the foreground and the darkened escarpment behind. Note the zigzag forest track in the right background.

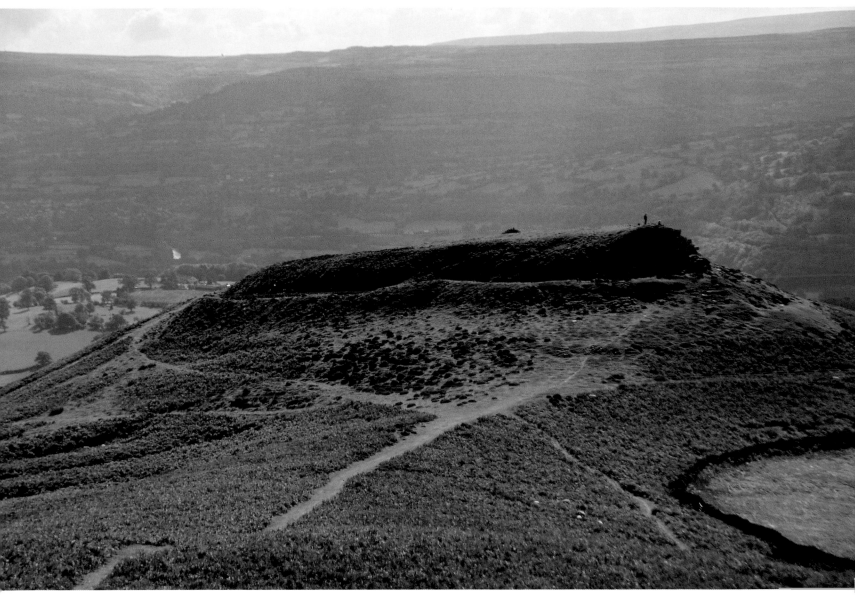

Table Mountain from Pen Cerrig-calch
It looks like a table from below but from this view you can clearly see the slope.
The walkers on the right of the frame give the impressive hillfort perspective.

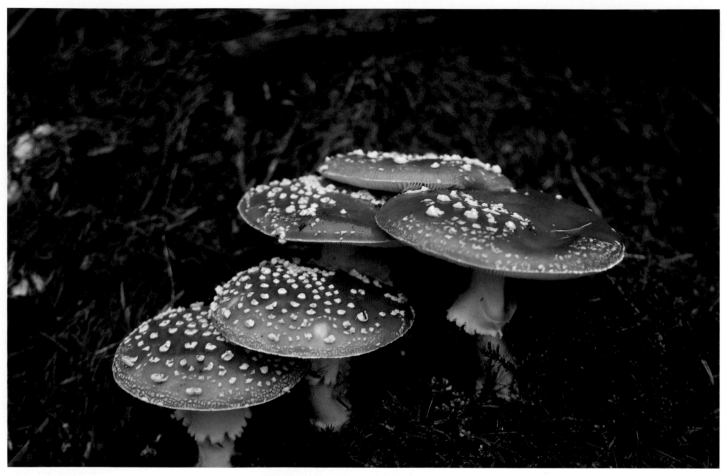

Fly Agaric, Mynydd Ddu Forest
Brightly-lit and colourful, all they need is a pixie sitting on them.

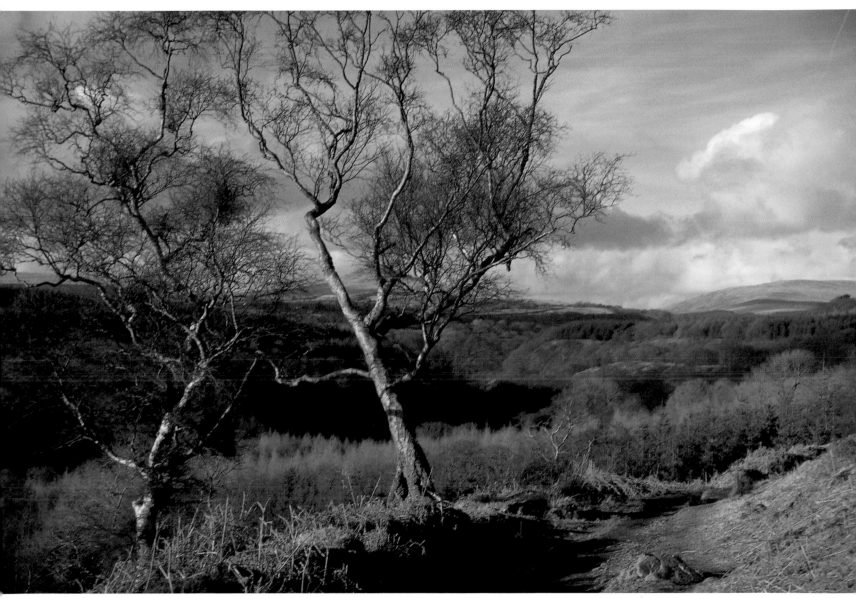

The flanks of Moel Penderyn
The late afternoon light brings out the real warmth of the winter colours on the hillsides of Fforest Fawr. The sun was low in the sky by the time I took this shot and I still had a good distance to go. I finished my walk in the dark.

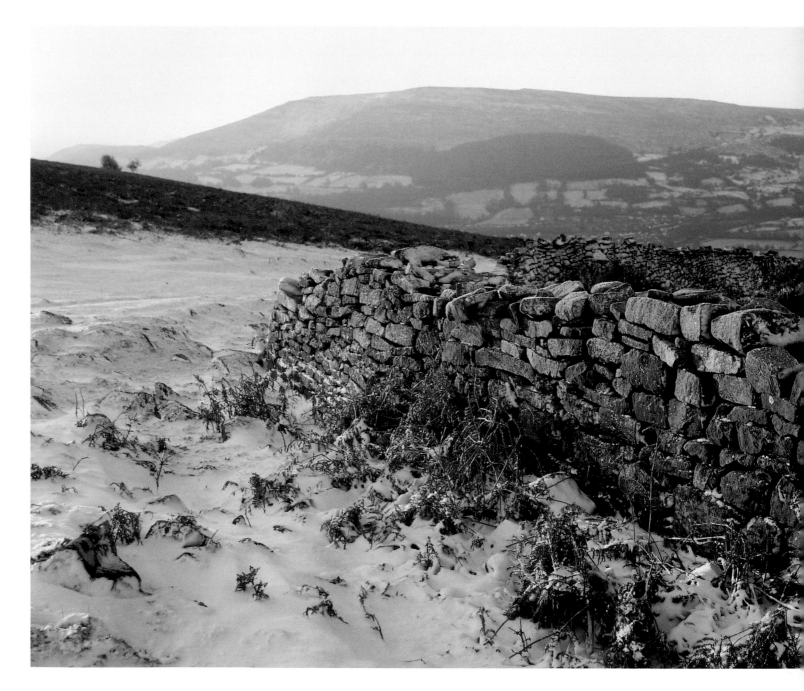

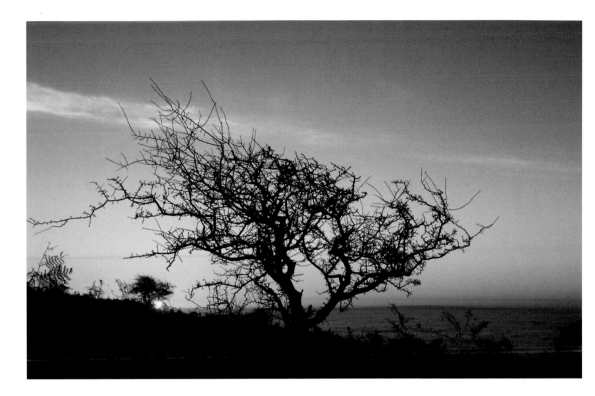

Above
Blackthorn, Mynydd Llanwenarth
The sinister outline of the hardy blackthorn trees which cling
doggedly to many of the steep mountain sides. This one is silhouetted
against a stunning sunrise on Mynydd Llanwenarth, above Abergavenny.

Left
Tumbledown Wall, Sugar Loaf
Early morning light catches a tumbledown wall on the snow-covered flanks
of the Sugar Loaf. The bulky hill in the background is The Blorenge.

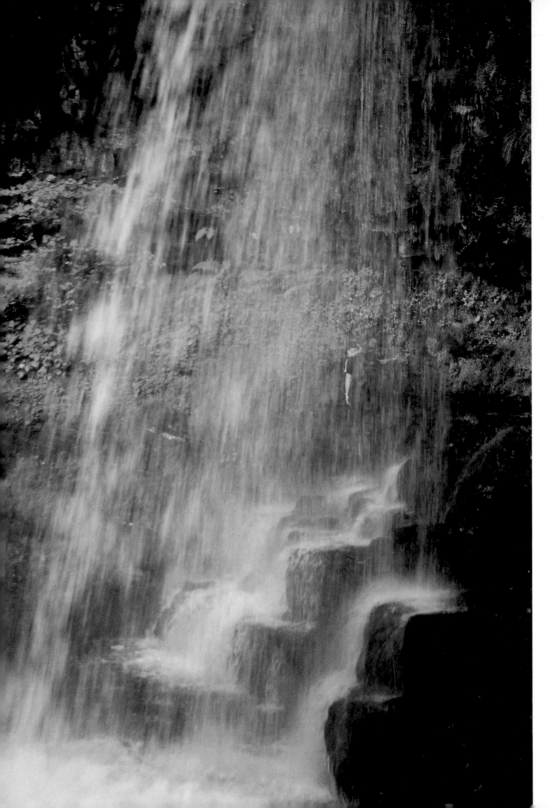

Sgwyd yr Eira
Like a scene from Lord of the Rings, Sgwyd yr Eira is a waterfall that you can really walk behind. It is very pleasant in summer as this shot shows, but it can be a different matter altogether when the Afon Hepste is in full spate.

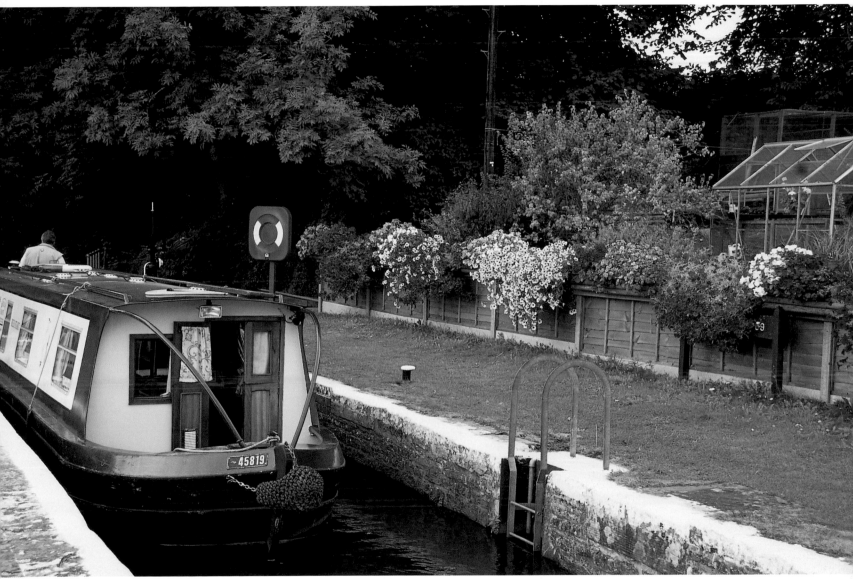

Brynich Loch
Colourful and restful, this image of Brynich Loch, near Brecon, shows yet another side to
the Monmouthshire and Brecon Canal which starts just a few kilometres from here.

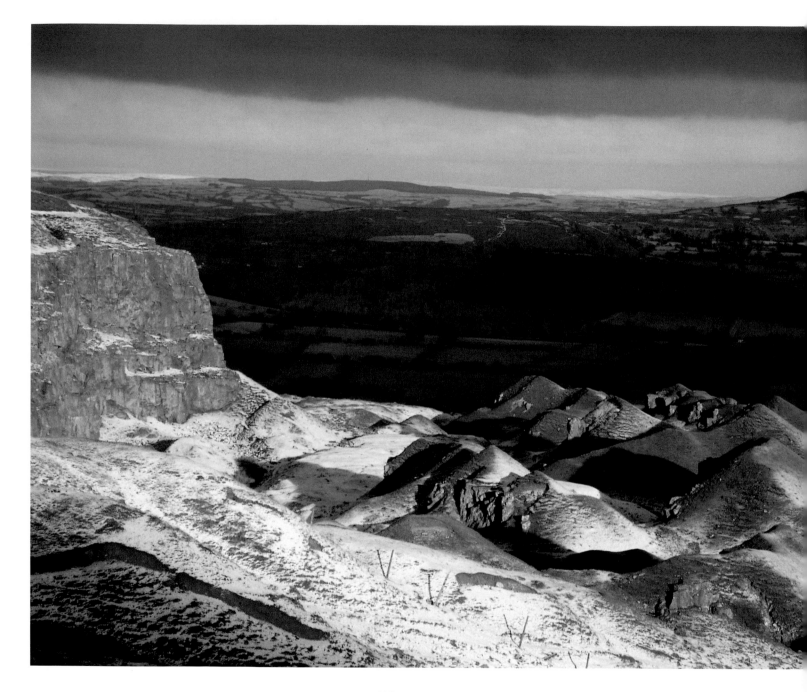

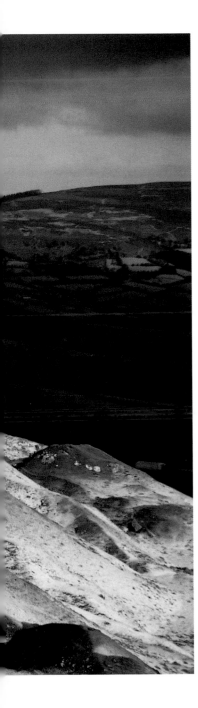

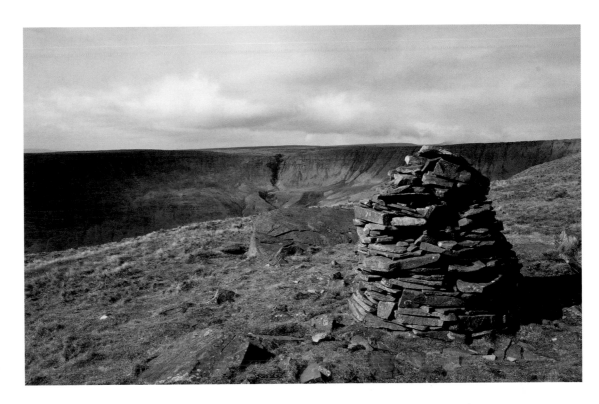

Above
Quarry spoil, Llangattock
A light dusting of snow coats the remnants of the limestone quarrying industry on
the Llangattock escarpment. The crags on the left host some decent rock climbs.

Left
Cairn, Cwar y Gigfran, Waun Rydd
This neatly constructed cairn sits on the southern end of Cwar y Gigfran, close
to the Canadian War Memorial. The escarpment behind is Craig y Fan Du and
behind that, it is just possible to make out the summit of Corn Du.

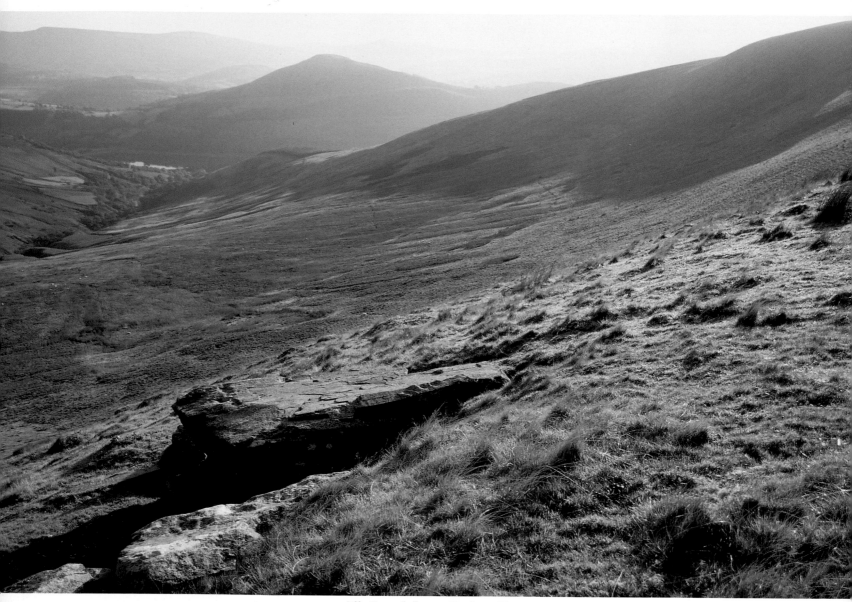

Allt Lwyd from Craig y Fan

Taking great care to avoid lens flare, I took this shot looking back along the sweep of Allt Lwyd from Craig y Fan. To the left you can see Tor y Foel towering above the Talybont Reservoir.

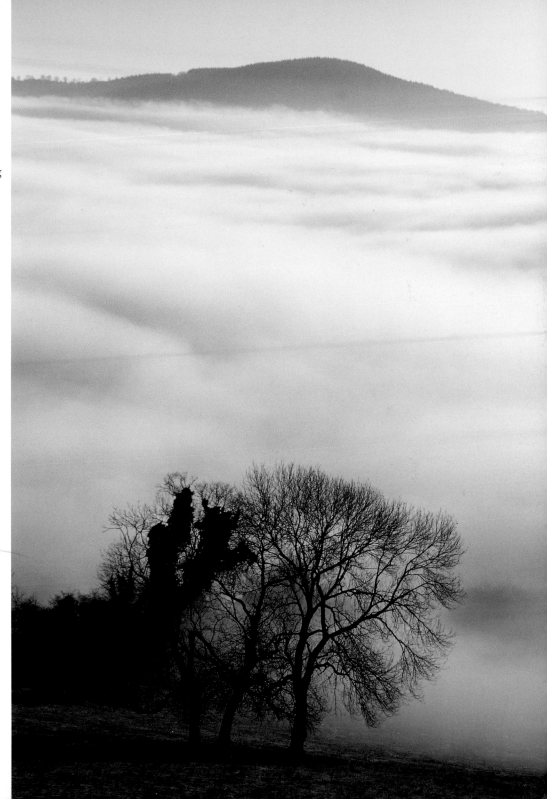

Trees and mist, Llwyn-du
Dropping down from Llwyn-du towards Abergavenny, my attention was caught by this small cluster of trees gradually emerging from the mist. Using a fairly large telephoto lens, Ysgyryd Fach, the wooded hill in the background, has been transformed into a respectably sized mountain.

113

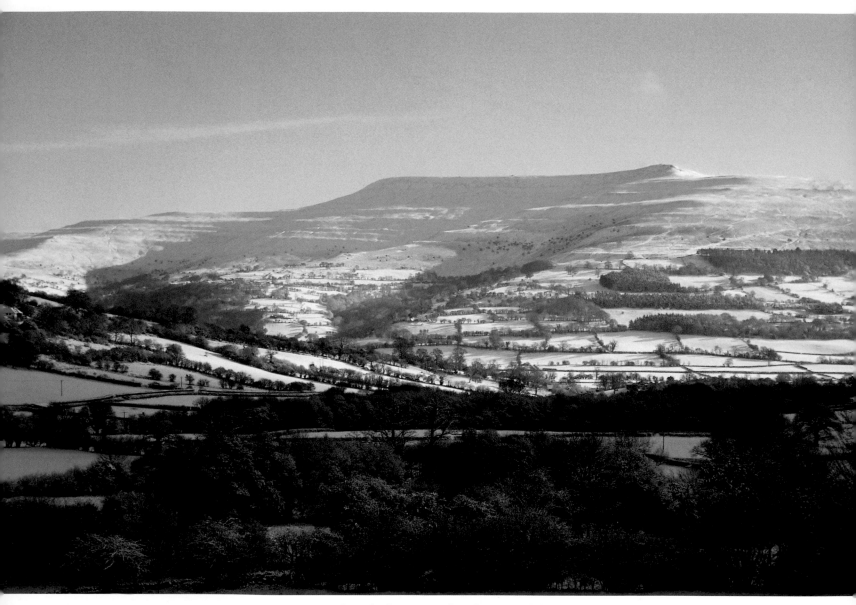

The Black Mountains from Bwlch
Viewed across a chocolate box landscape from the tiny village of Bwlch, this shot shows
the lofty outline of Pen Allt Mawr and Pen Cerrig-calch in their full winter coats.

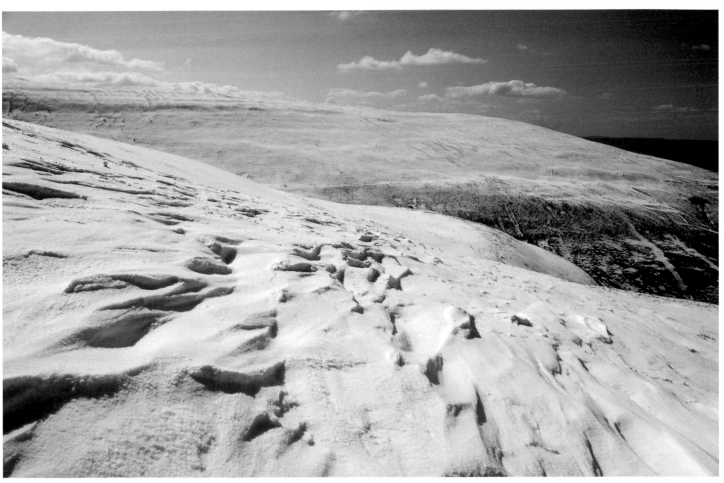

Snow Patterns, Mynydd Trumau

The wind has sculpted these interesting patterns into the snow on Mynydd Trumau,
close to the high spot of the Black Mountains, Waun Fach. Despite their southerly
location, the high mountains in the Park can have very harsh winters.

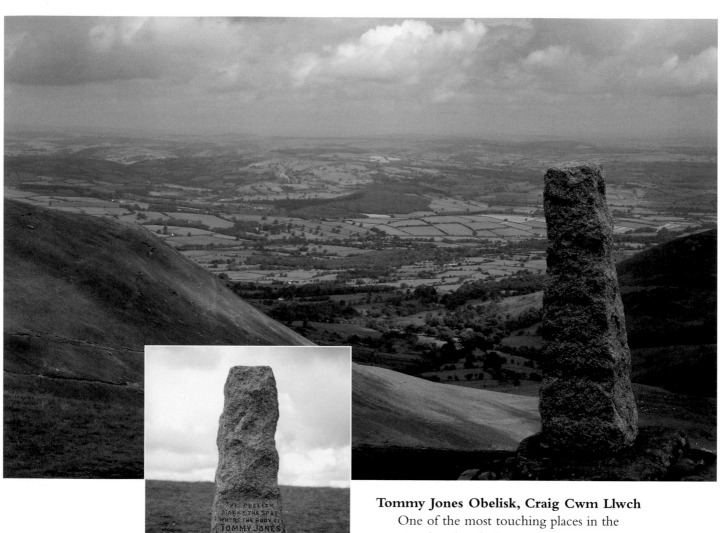

Tommy Jones Obelisk, Craig Cwm Llwch
One of the most touching places in the National Park. I find it incredibly difficult to pass the obelisk, high on the windswept slopes of Craig Cwm Llwch, without thinking about the poor boy and the terror he must have experienced alone up there in the dark.

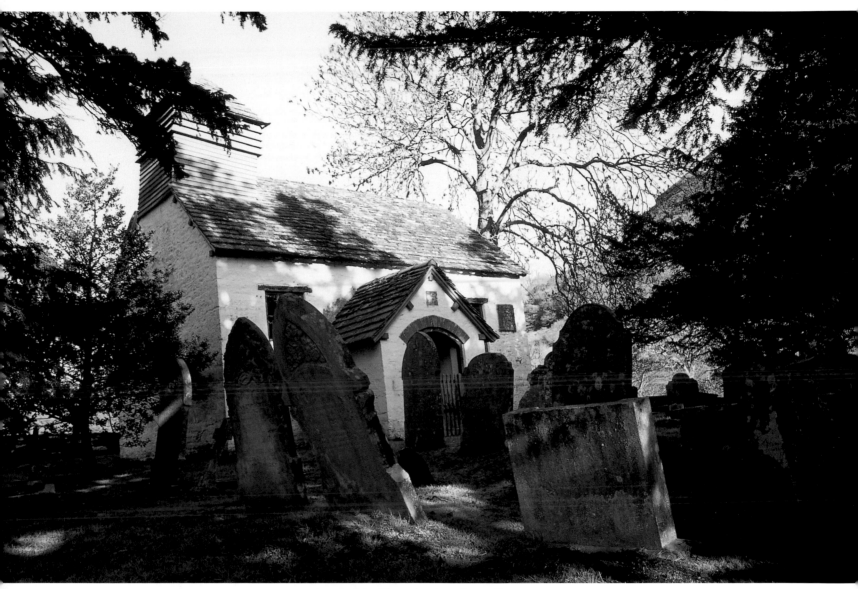

St Mary's Church, Capel-y-Ffin

This diminutive little church sits among fine mountain scenery in the Llanthony Valley. The tiny interior measures less than 8m by 4m (26ft by 13ft). It was built in 1736 although the porch was added later. Look closely and you should be able to make out the sloping belfry.

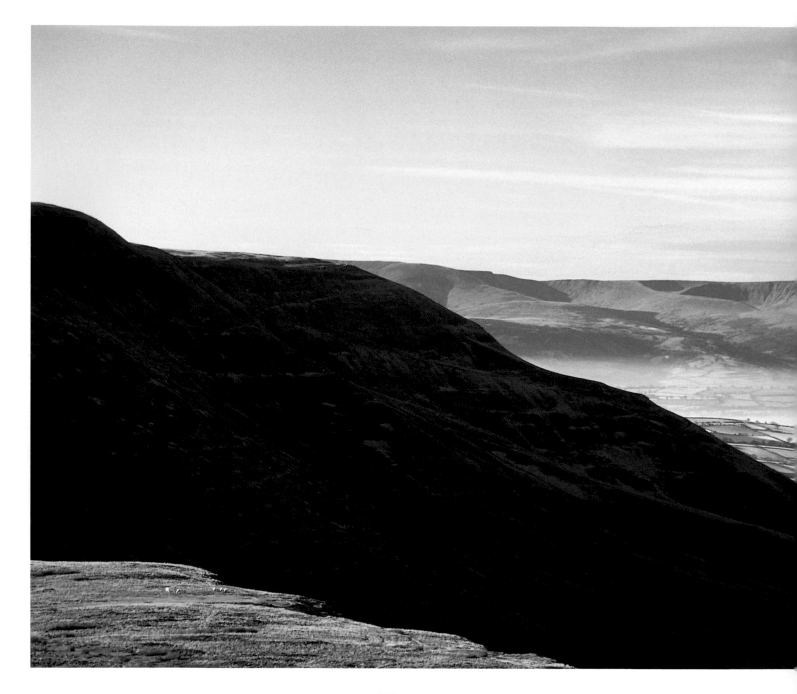

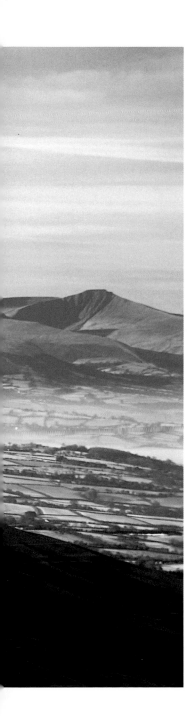

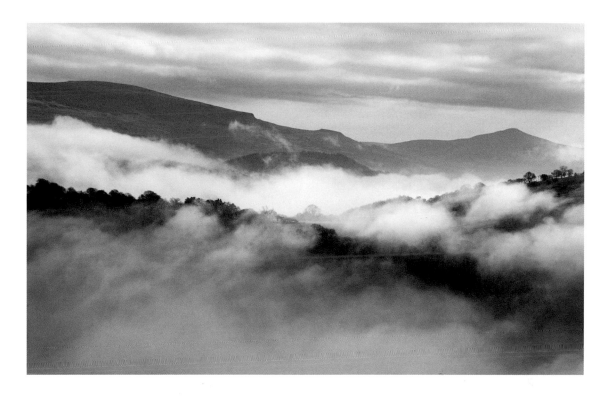

Above
Clouds over Pen Rhiw-calch
Climbing up onto Twyn-du from the Talybont Reservoir, I was mightily relieved to come
out above the clouds. This shot looks east, across the reservoir to the ridge which runs along
the southern shores. The distinctive peak of the Sugar Loaf makes up the background.

Left
The Brecon Beacons from Rhiw Y Fan
From the northern slopes of the Black Mountains, it is possible to see
right across to the Brecon Beacons themselves. Pen y Fan is far right with
Cribyn, Fan y Big and Waun Rydd all visible as your eyes move back east.

119

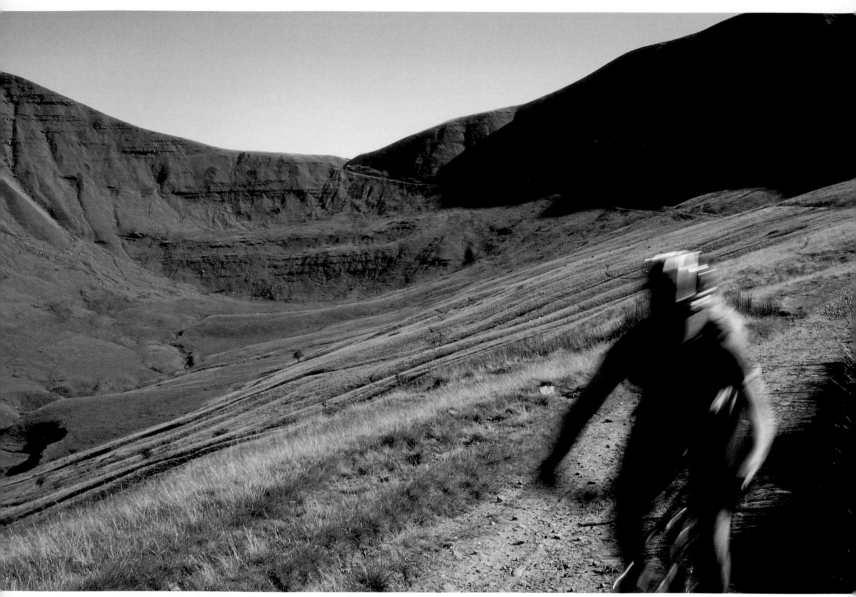

Mountain Biking, Cwm Cynwyn
The natural amphitheatre of Cwm Cynwyn cradles an ancient road which makes for one of the finest mountain bike trails in the UK. It is a long climb up to the Gap from the Neuadd Reservoirs on the other side, but the descent makes it all worthwhile.

120

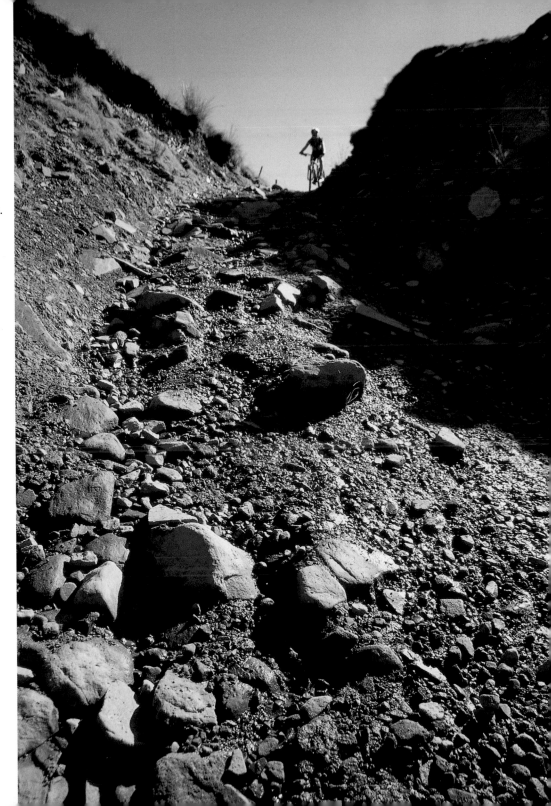

Mountain Biking, Gap Road
Dry and often rubble-strewn, the ancient tracks and ways which criss-cross the Beacons attract many mountain bike enthusiasts to the area. This shot was taken in a deep gully near the Neuadd Reservoirs.

121

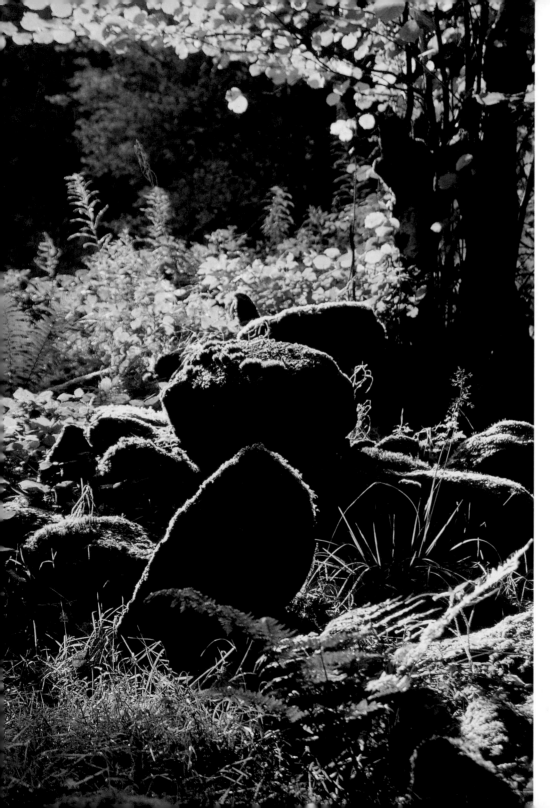

Rocks and Ferns, Blaen-y-Glyn
The backlit moss on the rocks is complemented by the bright greens of the grass, ferns and leaves to make an atmospheric shot of a tumbledown old wall near Blaen-y-Glyn. This sort of scene can be found on the floors of many of the ancient deciduous woodlands in the area.

122

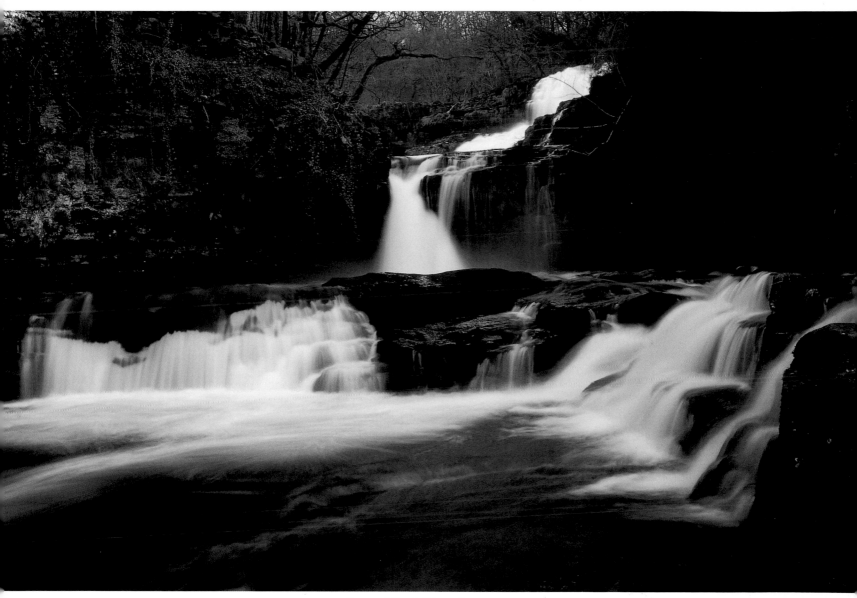

Sgwyd Isaf Clun Gwyn
One of the most spectacular of the 'Waterfall Country' waterfalls, the cascades zigzag down
the drop giving the impression that the gushing water is coming at you from all angles.

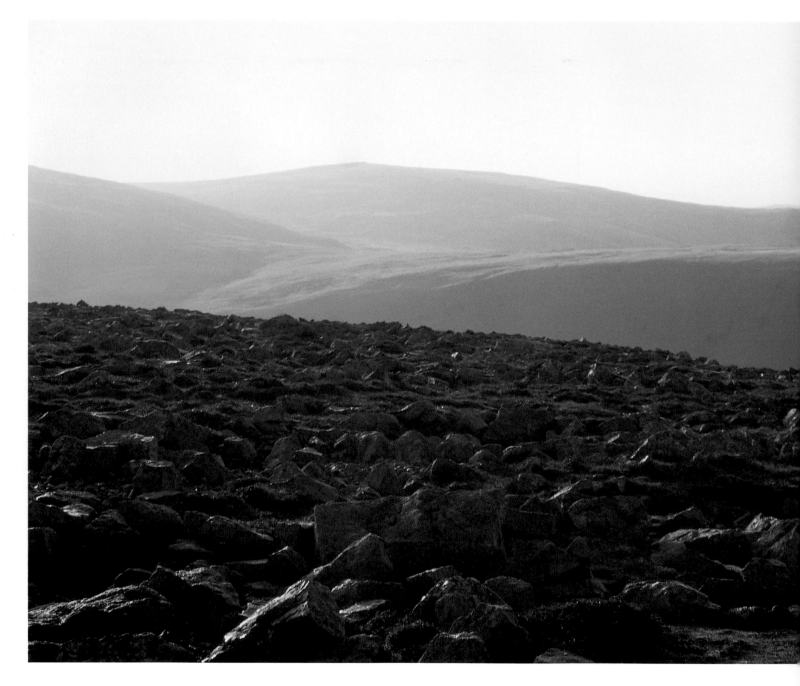

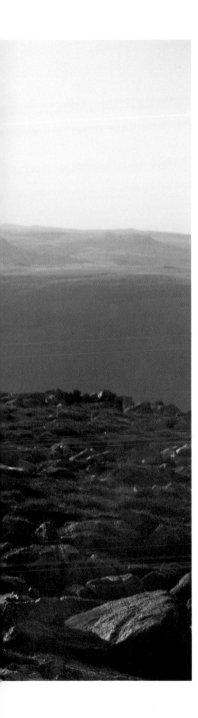

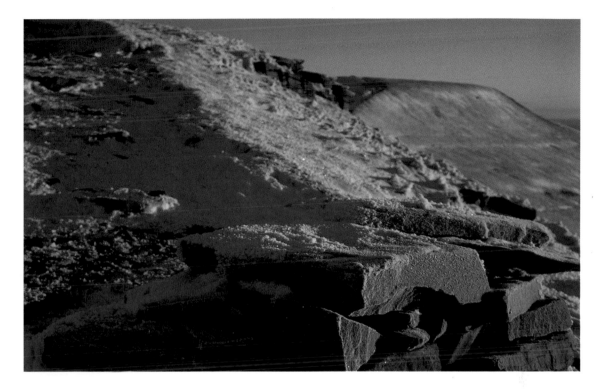

Above
Frosted rocks, Corn Du
The early morning sun illuminates a few slabs of old
red sandstone on the flanks of Corn Du.

Left
Carreg Lwyd, Mynydd Ddu
The austere landscape of the western edge of the Mynydd Ddu, or Black Mountain.
This shot was taken from the summit of Garreg Lwyd, looking
north-east towards Foel Fraith. Appropriately, the name means Grey Rock.

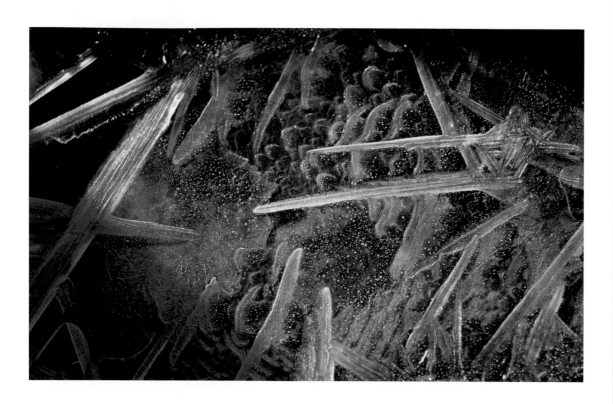

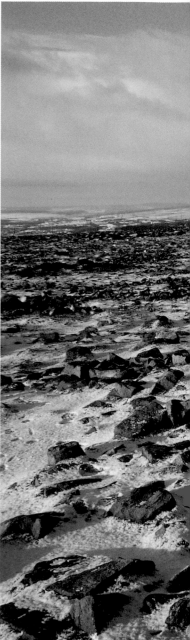

Above
Iced puddle, Rhiw y Fan
An abstract image of an iced-over puddle high in the mountains. During the
cold months, puddles like this can go for weeks or months without thawing.

Right
Summit, Pen-cyrn
The bleak summit of Pen-cyrn. This featureless moorland was the scene of
my very first visit to the National Park – so it means a lot to me. It can be heavily
over-grazed in summer, but in winter it really does feel like a wilderness.

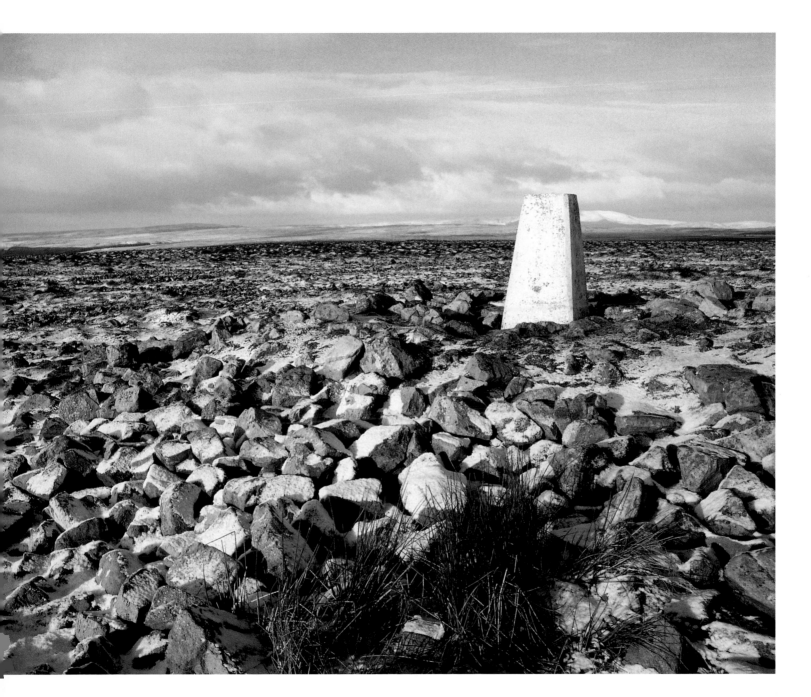

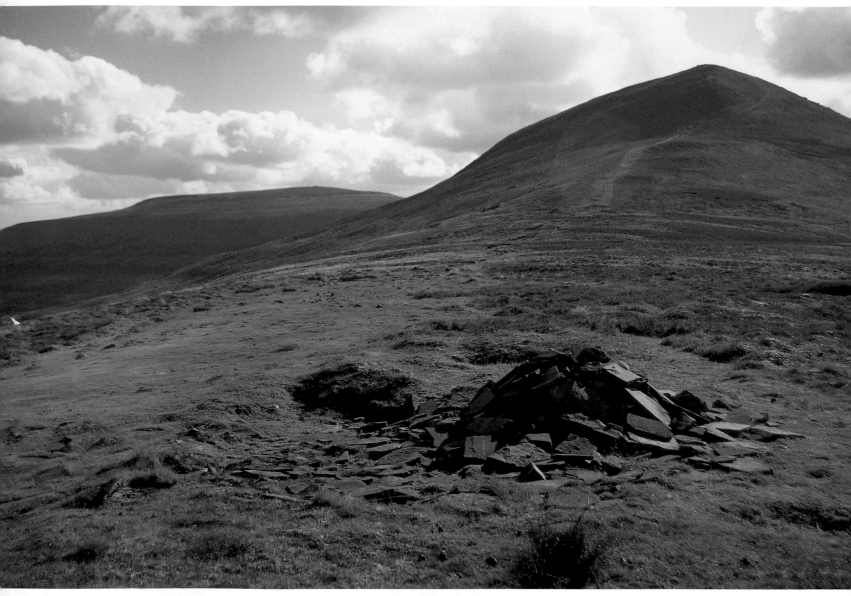

Pen Allt Mawr

On first impression, the skyline circuit of the Black Mountains looks quite straightforward, with little in the way of descents and re-ascents. In reality there are a number of steep sections, like this one on the northern flanks of Pen Allt Mawr.

Icicles, Fforest Fawr
There are few things in nature as spectacular as frozen waterfalls; they really do seem to come straight from fairy tales. This one, shown against a beautiful cerulean sky, was taken near Fan Fawr.

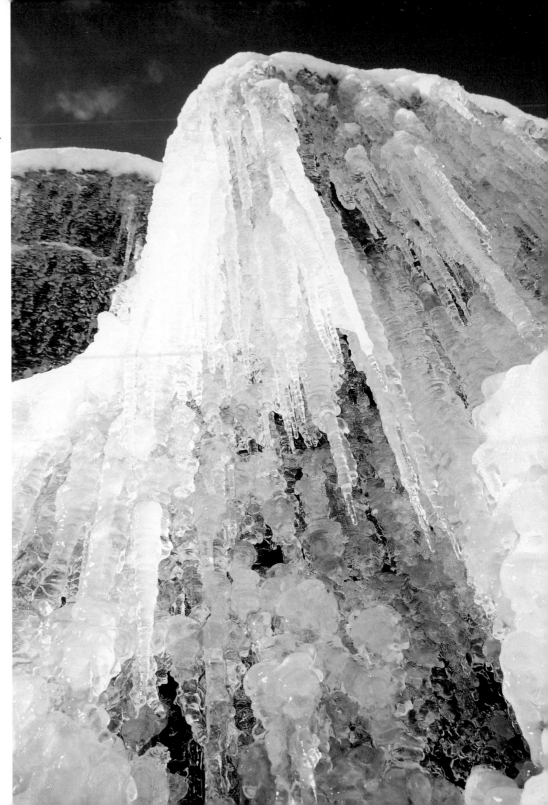

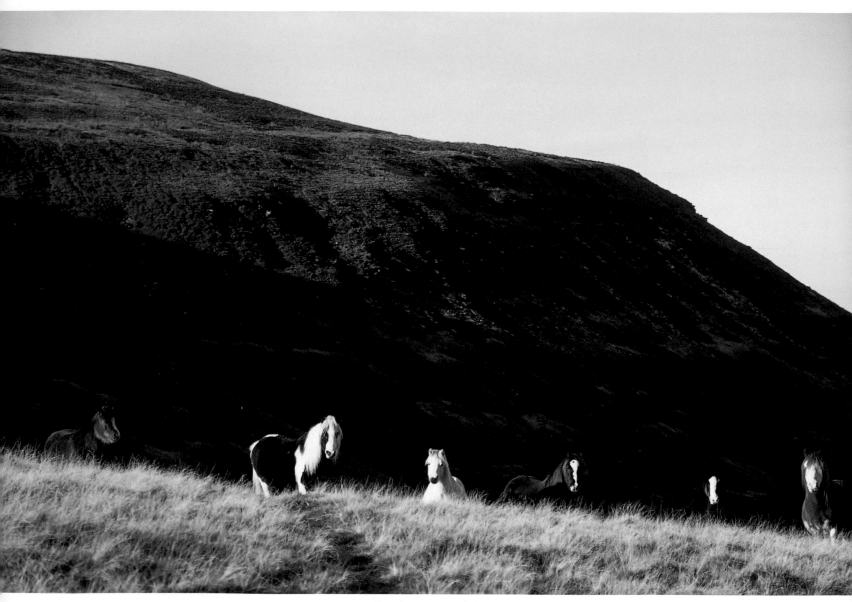

Ponies, Gospel Pass

A group of curious wild ponies track my progress as I traverse the northern ridge of the Black Mountains near the Gospel Pass. They didn't drop their guard until I packed away my tripod and walked off.

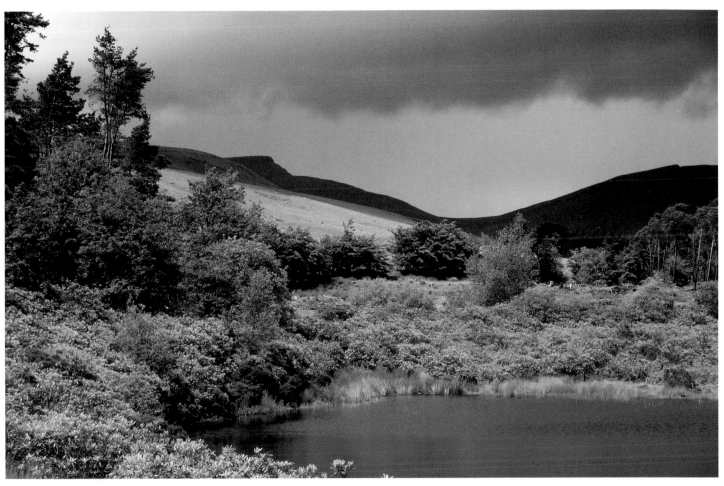

Pen y Fan from the Neuadd Reservoirs

Rhododendrons add a touch of colour to the banks of the Lower Neuadd Reservoir. The high mountains look a lot less sinister from the south, but the building storm clouds still give the whole scene a menacing feel.

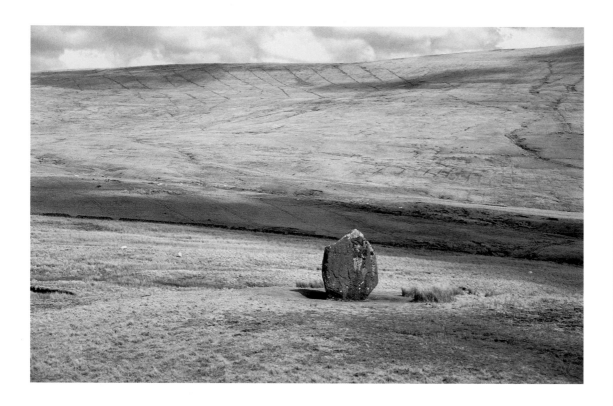

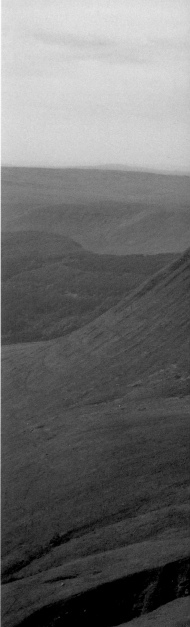

Above
Maen Llia, Fforest Fawr
Set on barren moorland between Fan Dringarth and Fan Nedd, this huge standing stone
is impressive. It is one of two that stand within a couple of miles of each other: Maen Madoc is
just a short distance to the south and it also stands alongside the Roman Road of Sarn Helen.

Right
Self-portrait on Craig y Fan Du
After camping close by, I sat on this rock to warm myself in the early
morning sunshine. For me, the picture captures the magic of the moment.

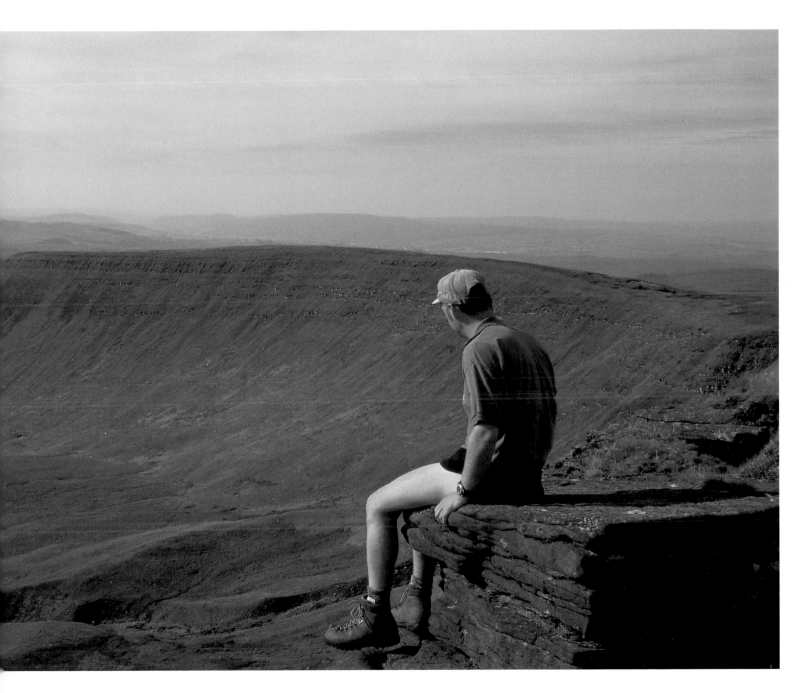

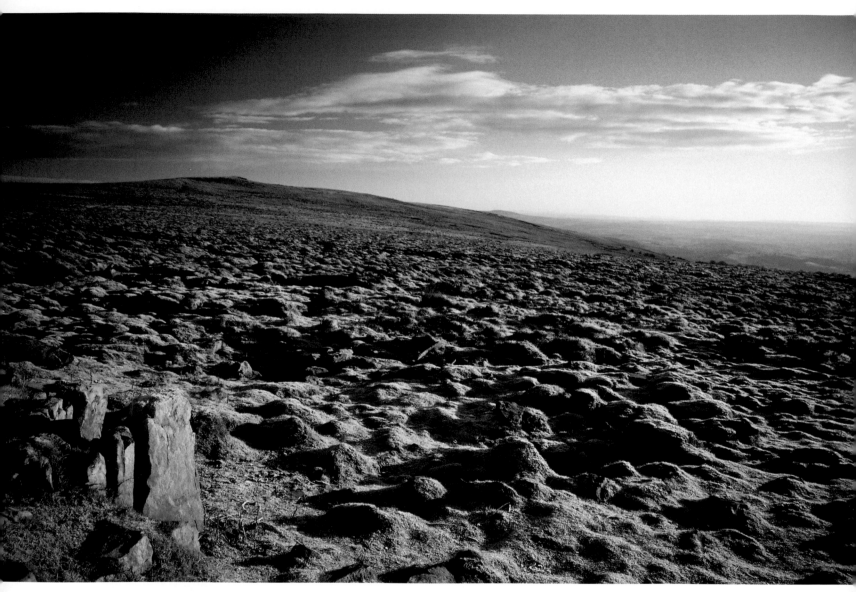

The Blorenge
Once the most southerly managed grouse moor in the UK, the heathery plateau of The Blorenge still echoes to the disgruntled sound of their alarm call. This shot of the summit, taken from the Foxhunter car park, is of surely the easiest mountain to climb in the whole National Park.

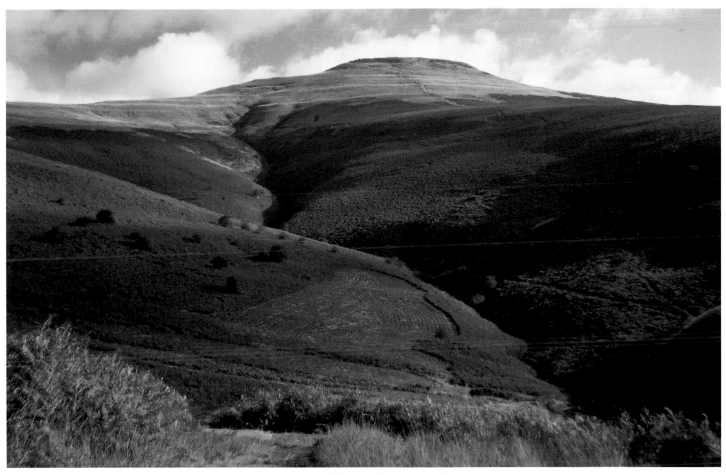

Sugar Loaf from the West Ridge

The distinctive conical outline of the Sugar Loaf makes it one of the best-known and most climbed mountains in the whole National Park. The pronounced valley which cuts deeply into the western flanks also serves as the Monmouthshire/Powys boundary.

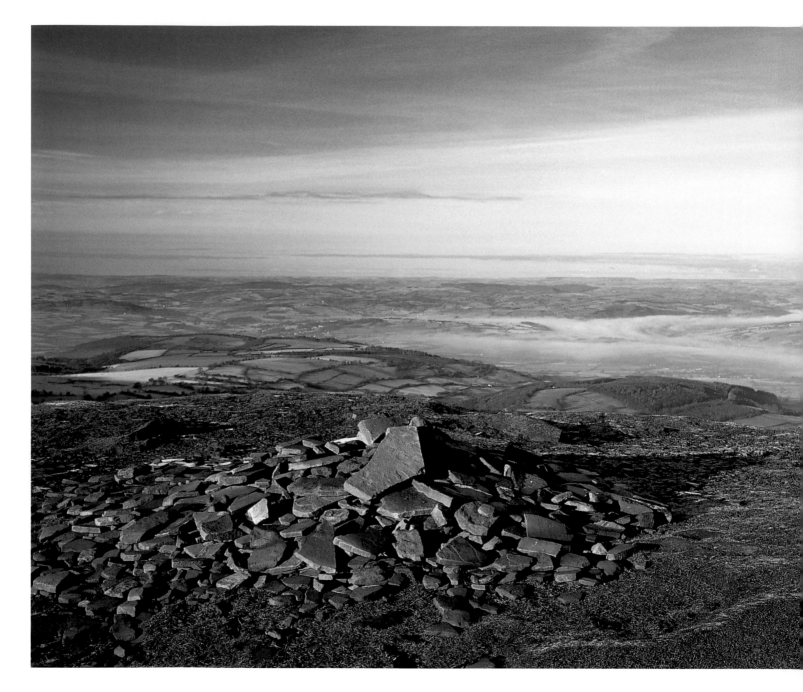

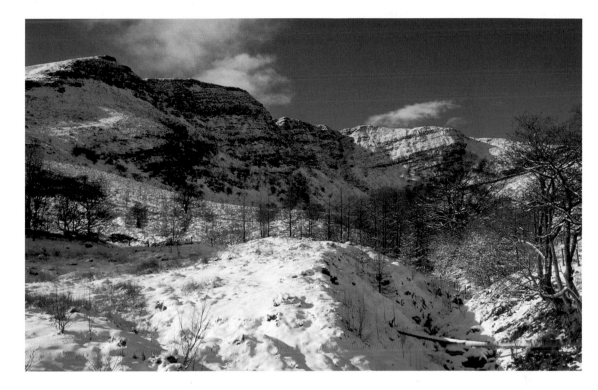

Above
Craig Cerrig-gleisiad
Snow clings doggedly to the steep crags of the National Nature Reserve of
Craig Cerrig-gleisiad. The north-facing cirque is a unique environment which
hosts many species of alpine and Arctic plants.

Left
Wye Valley from Twmpa
Looking north from Twmpa over the Wye Valley you can easily make out the
strips of cloud which trace the line of the majestic river as it heads south from
Builth Wells. Fifteen minutes after I took this shot, the cloud had gone.

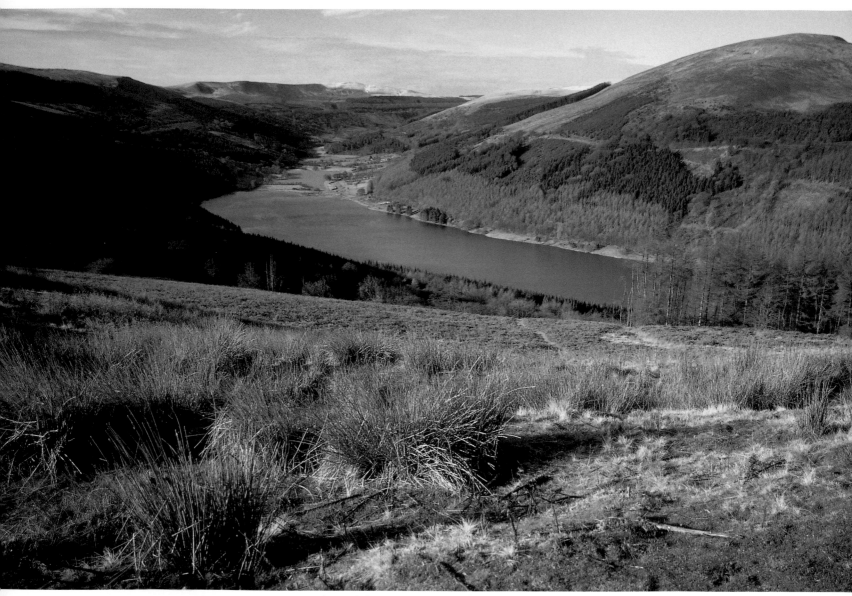

The Talybont Reservoir from Tor y Foel

Looking south-west from the foot of Tor y Foel, you get a great view over the Talybont Reservoir to the small outlying peak of Allt Lwyd and also up into the high mountains of the National Park, here dusted with a coating of snow.

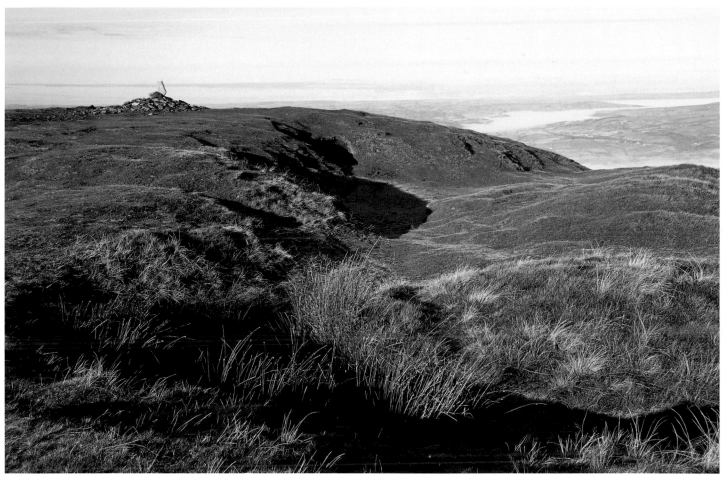

Twmpa Summit

You've got to feel sorry for a mountain called Lord Hereford's Knob. So for that reason I tend to use
its Welsh name of Twmpa, which does seem a little more dignified. A small cairn marks the summit.

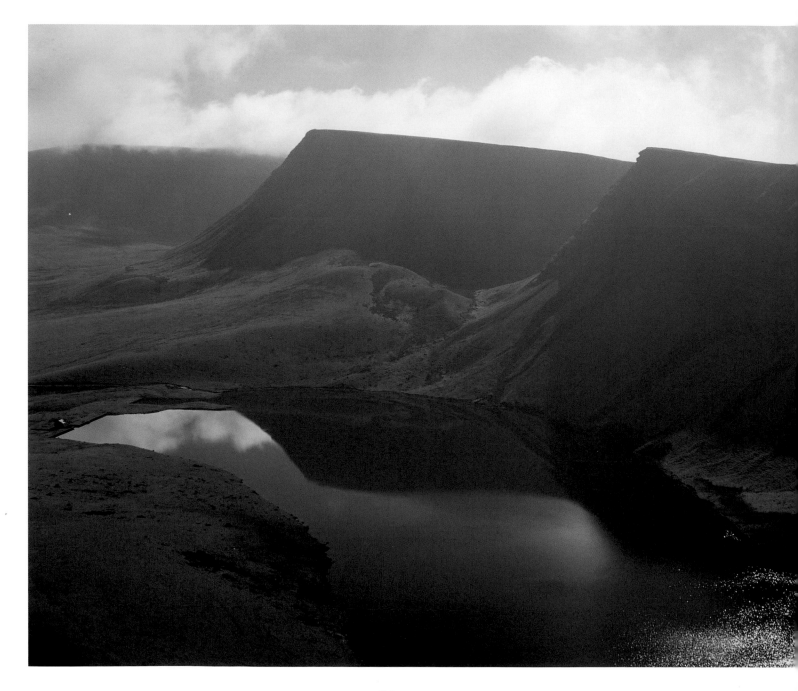

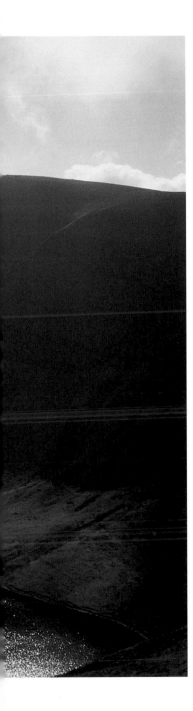

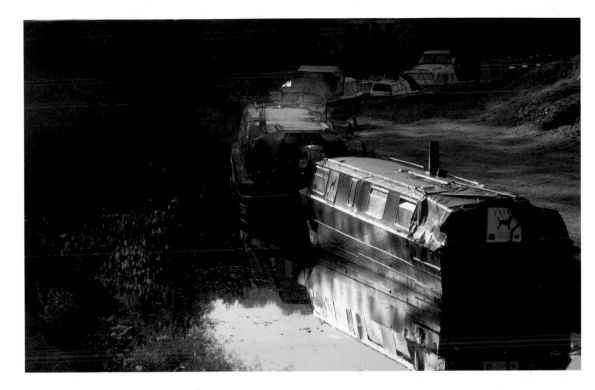

Above
Canal Boats Gilwern Wharf
If only a photograph could capture a smell! This tranquil canal
scene, at Gilwern Wharf, was made all the more idyllic by the aroma
of cooking bacon drifting slowly up from one of the boats.

Left
The Carmarthen Fan from above Llyn y Fan Fach
For me, one of the finest views in the National Park, taken from a place which
I have spent many a fine hour with only the breeze and ravens for company.

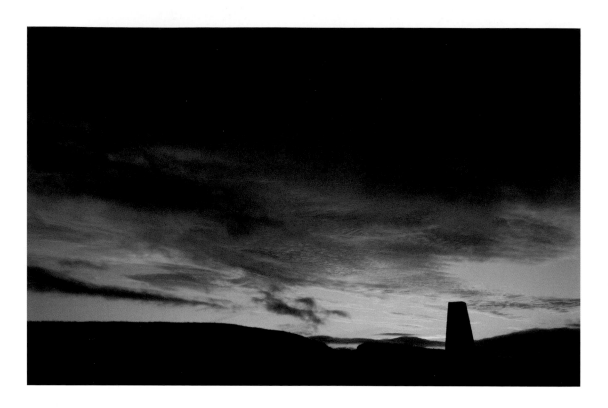

Above
Skyscape and trig point, Sugar Loaf
Most mountain summits are somewhat defaced by ugly concrete triangulation pillars,
or trig points as they are usually known. Sugar Loaf is no exception but it adds to
this shot, creating a strong silhouette against this wonderful post-sunset summer sky.

Right
Pen y Fan and Corn Du from Cefn Cwm Llwch
The distinctive silhouette of the twin peaks seen as a reflection
in a tiny mountain tarn on Cefn Cwm Llwch.

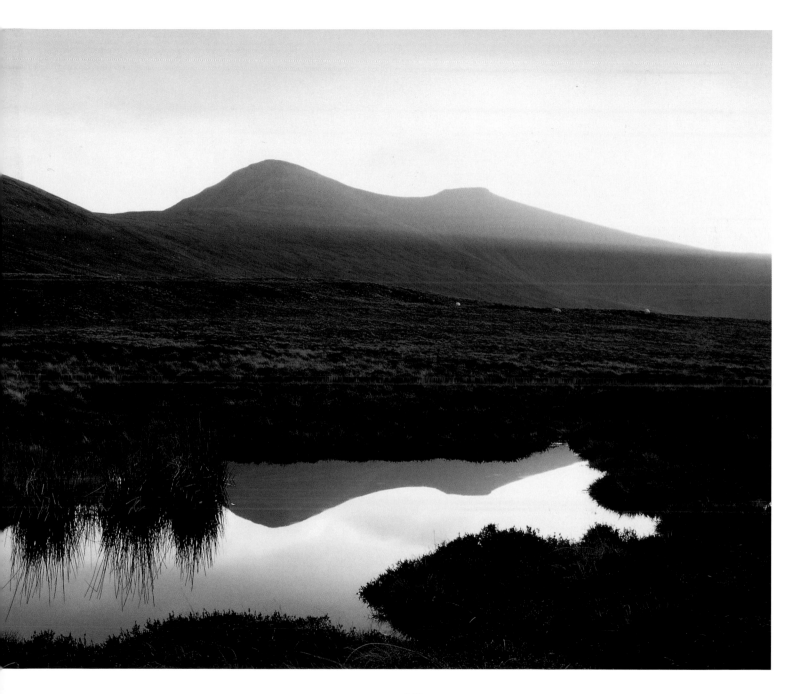

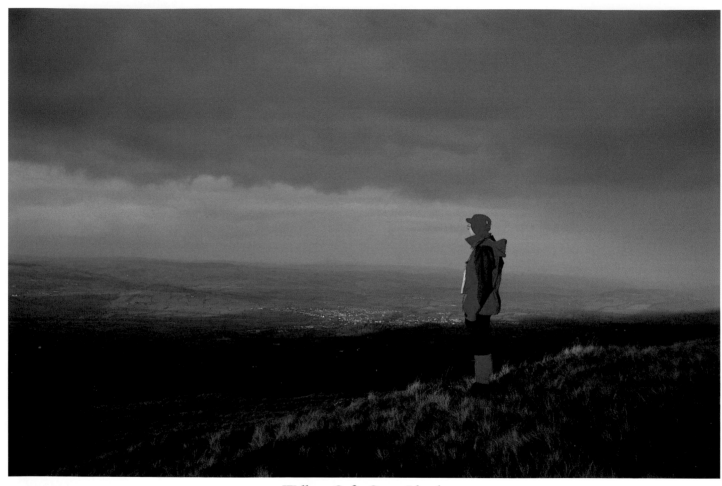

Walker, Cefn Cwm Llwch

After a dull day, the sun emerged from beneath the cloud for a few brief seconds before dropping down behind the horizon. The picture was taken on Cefn Cwm Llwch, looking north over Brecon.